Bibliography

Sekai no kessakuki shirizu (Masterpiece Machines of the World Series), Bunrindo
Dainijisekaitaisen bukku shirizu (World War II Book Series), Sankei Shuppan
Raifu dainijisekaitaisenshi shirizu (Life's World War II History Series), Time Life Books
Sekai no gunyouki (Military Machines of the World), Koku Journal
Sekaigunyouki nenkan (Military Machines of the World Almanac), Air World
Sekai no sensha (Tanks of the World), Sensha Magazine
Koukuu fan ("Aviation Fan"), Bunrindo
Air World, Air World
Panzer, Sunday Art-sha
Sensha magajin ("Tank Magazine"), Delta Shuppan
Grand Power, Delta Shuppan
Gunji kenkyuu ("Military Research"), Japan Military Review
Maru, Choushobou
Model Art, Model Art-sha
Sekai no sensha nenkan (Tanks of the World Almanac), Sensha Magazine
Jieitaisoubinenkan (National Self-defense Equipment Almanac), Asagumo Shinbunsha
Gakken no X zukan: Gunyouki (Military Machines), Sentouki (Battle Machines), Bakugekiki (Bombers),
Gunkan (Warships), Senkan (Battleships), Koukuu bokan (Air Force Depot Ships), Sensuikan (Submarines).
Rekishigunzou taiheiyo senshi shirizu (Pacific War History Series), Gakken
Sekai no Kansen (Warship Bridges of the World), Kaijinsha
Seikai no sensuikan, Nihon no sensuikan, Sekai no koukuu bokan
(Submarines of the World, Japanese Submarines, Air Force Depot Ships of the World, Scora
Saishingunyoukizukan (Newest Military Machines Illustrated Guide), Tokumabunko
Sekai no saishinheiki no katarogu (Catalog the World's Newest Arms), Sanshusha
Daizukai sekai no bukki 1, 2 (Illustrated Dictionary of Weapons of the World, I and II), Green Arrow Shuppansha
Sensha mekanizumu zukan (Illustrated Guide of Tank Mechanics), Grand Prix Zukan

HOW TO DRAW MANGA: Guns & Military Volume 2
by Ichiro Kamiya, with Shin Ueda

Copyright © 2000 Ichiro Kamiya
Copyright © 2000 Shin Ueda
Copyright © 2000 Graphic-sha Publishing Co., Ltd.

This book was first designed and produced by Graphic-sha Publishing Co., Ltd.
in Japan in 2000. This English edition was published by Graphic-sha Publishing Co., Ltd.
in Japan in 2004.

Graphic-sha Publishing Co., Ltd.
1-14-17 Kudan-kita, Chiyoda-ku, Tokyo 102-0073 Japan

Illustrators: Ichiro Kamiya, Shin Ueda
Art director: Motoi Jige
Collaborator: Isao Ito, Naoki Kobayashi
Main title logo design: Hideyuki Amemura
Planning editor: Sahoko Hyakutake (Graphic-sha Publishing Co., Ltd.)
English edition layout: Shinichi Ishioka
English translation management: Língua fránca, Inc. (an3y-skmt@asahi-net.or.jp)
Foreign language edition project coordinator: Kumiko Sakamoto (Graphic-sha Publishing Co., Ltd.)

Distributed by
Japanime Co., Ltd.
2-8-102 Naka-cho, Kawaguchi-shi,
Saitama 332-0022, Japan
Phone /Fax: +81-(0)48-259-3444
E-mail: sales@japanime.com
http:// www.japanime.com

First printing: August 2004

ISBN: 4-7661-1262-8
UPC: 8-24869-00035
Printed and bound in China by Everbest Printing Co., Ltd.

HOW TO DRAW MANGA

GUNS & MILITARY

VOLUME 2

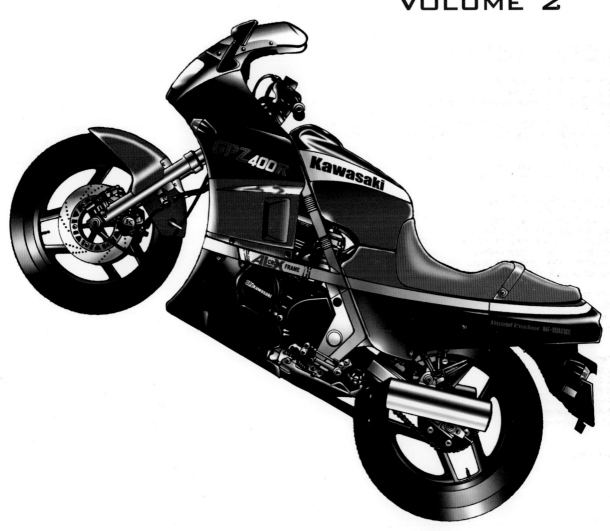

Now that your manga characters are armed and ready, it's time to send them off on some dangerous, far-flung missions. Whether by land, sea or air, this book will show you how to get them there! This, the second volume in the "Guns and Military" component of the popular "How to Draw Manga" series, features blueprint-quality illustrations of tanks, battleships, gunboats, helicopters, jet fighters and long-range bombers from all of the world's major military powers, past and present. And just in case you've got a character who isn't exactly a "team player," we've included a few dozen illustrations of easy-ridin' motorcycles as well. Because getting to the battle is half the fun!

TABLE OF CONTENTS

Motorcycles ...003
 VMAX1200 ...004
 GPZ400R ..005
 RGV-r 250SP ..006
 Vulcan ..007
 Tosho Pandora TS1, Falcorustyco008
 TDM850 ..009
 CBX1000 ...010

Aviation ..012
 Fighter Planes ..012
 Bomber Planes040
 Attack Helicopters060

Warships ..064
 Battleships ...064
 Aircraft Carriers074
 Cruisers ..090
 Destroyers ..098
 Stealth Warships104
 Submarines ...106

Military Vehicles120
 Battle Tanks ...120
 Self-propelled Guns126
 Armored Personnel Carriers130

Avitation ...132
 Unreal Aircraft ..132
 Largest in the World134

MOTORCYCLES

Name: VMAX1200
Maker: Yamaha
Displacement: 1,198cc
Maximum output: 97ps/8,000 rpm
Maximum torque: 9.3kg-m/6,000 rpm
Dry weight: 264kg
Engine type: DOHC 4-valve V-type 4-cylinder
Overall length: 2,300mm
Overall height: 1,175mm
Seat height: 765mm
First released: 1985

The Yamaha VMAX1200 has a giant chassis befitting its beautiful bodywork and wild power. The boa stroke of this water-cooled DOHC-V-type 70-degree 4-cylinder engine is 76 x 66mm. Connecting the front and back exhausts manifold, the V-Boost engine exceeds 6,000 RPM. Utilizing a high-volume air cleaner and muffler, it realizes 145 horsepower. The Japanese domestic model does not come equipped with a V-Boost system but from about 145 km/h in top gear the acceleration is good and very fast. The acceleration from idling is particularly amazing. The time from 0 to 400 is a mere 10 seconds. The entire bulk of the metal accelerates at once, making this a total drag machine. There was no intention to reduce the weight of the machine, so the use of plastic is minimal while that of metal is extensive. The VMAX represents the new generation of American-style hyper bikes.

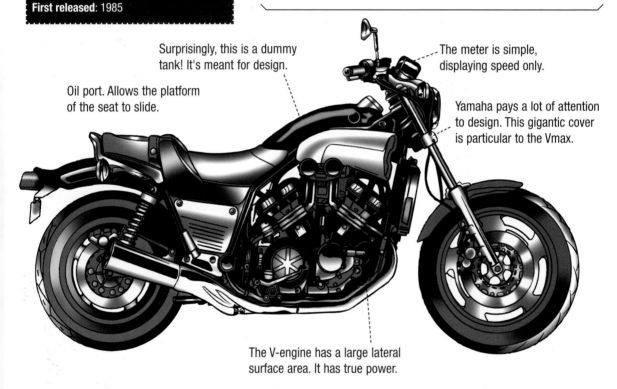

Surprisingly, this is a dummy tank! It's meant for design.

Oil port. Allows the platform of the seat to slide.

The meter is simple, displaying speed only.

Yamaha pays a lot of attention to design. This gigantic cover is particular to the Vmax.

The V-engine has a large lateral surface area. It has true power.

What bike is used at test courses for large-sized bike licenses?
The oscillation of this V-type engine is actually minimal. When idling, it has a quietness that is hard to imagine for a bike with this kind of exterior. The seat is higher than it looks and the driver needs strength to handle the powerful engine. I've seen the VMAX used as a police-training vehicle, but a bike such as this is simply too powerful for beginners.

The design of the speedometer is good.

The wide seat has a height of 765 millimeters. (The total height is 1,175 millimeters.) Riders under 170 centimeters in height will find this difficult to handle.

The tachometer and the warning lamp are above the dummy tank.

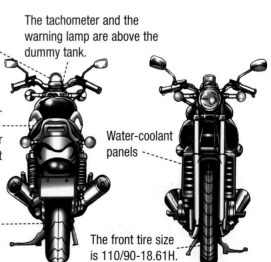

Water-coolant panels

The rear tire size is pretty thick. 150/90-15M/C.74H

The front tire size is 110/90-18.61H

GPZ400R

Different than a car, the only "normal" colors you're likely to see on a motorcycle are on the tank and fenders. A model with these kinds of curves wears wild colors well.

Name: GPZ400R
Maker: Kawasaki
Displacement: 398cc
Maximum output: 59ps/12,000 rpm
Maximum torque: 3.6kg-m/10,500 rpm
Dry weight: 176kg
Engine type: Water-cooled 4-stroke
 4-cylinder DOHC 16-valve
Overall length: 2,095mm
Overall height: 1,180mm
Overall width: 675mm
Seat height: 770mm
First released: 1985

This street bike debuted when racer replicas were at their peak. Kawasaki obstinately insisted on a two-valve air cooler. For the 900cc Ninja, however, the 4-valve water-cooled 400cc engine was introduced. From that time onward Kawasaki also put its efforts into aeronautics and achieved a CdA-based 0.29 high aerodynamic feature in this GPZ400R. The engine, which is different from that of the Ninja, lacks a side cam chain. This gives the bike a powerful quality with its acceleration and top speed, appropriate for its image. Setting aside likes and dislikes, 16-inch front and back tires, which are unusual even now, aren't necessarily a success. I've also ridden the 1,000cc class GPZ1000RX and can understand its good reputation. The front-back and up-down aluminum cross frame used for the GPZ400R was improved and was also inherited by the newest model of the same class, the ZZ-R400. This sense of advancement comes through now as well. As the naked version of the GPZ400R, the FX-400R takes its name from the once-famous. Z-FX but the frame in the front and the tail lamp have been changed, and it was released commercially after being given a exhaust header.

Different than a car, the only "normal" colors you're likely to see on a motorcycle are on the tank and fenders. A model with these kinds of curves wears wild colors well.

Even in rain these unequal beach discs exhibit stable braking power. The highly respected Uni-Trak Rear Suspension System.

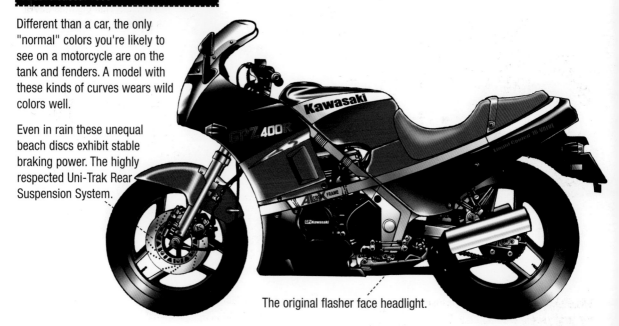

The original flasher face headlight.

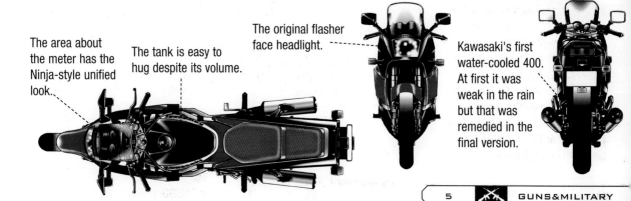

The area about the meter has the Ninja-style unified look.

The tank is easy to hug despite its volume.

The original flasher face headlight.

Kawasaki's first water-cooled 400. At first it was weak in the rain but that was remedied in the final version.

RGV-r250SP

This is a Grand Prix machine and racer replica. With the introduction of this model, the 90-degree V-twin engine layout was done away with and the '95 Works Racer 70-degree V-twin layout employed. The technologies created for the racer are also used in this commercial 2-stoke machine; these include the air intake, the electronically control TMR32 carburetor and the two-tier screen cowl. The change to a cell motor meant the removal of the kick pedal and changed the engine's ignition. The consideration behind this was not the rider: Getting rid of the kick pedal allowed for greater flexibility in the layout of the engine. The changes and flexibility in engine layout meant the front and back length of the engine was 40mm shorter than in previous models, helping to concentrate the mass. The intake was also shortened by 10mm, enhancing the response of the engine. From whatever perspective, even though it is a Grand Prix machine, the technology wasn't overdone. But emissions regulations have brought production of this model to a halt.

The long, slanting nose enhances the aerodynamics. It extends 110 millimeters beyond the front axle.

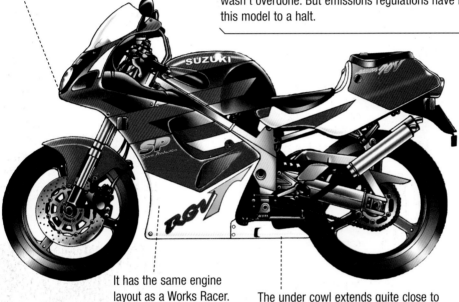

It has the same engine layout as a Works Racer.

The under cowl extends quite close to the rear tire, improving the aerodynamics.

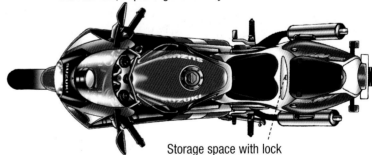

Storage space with lock

Name: RGV-r250SP
Maker: Suzuki
Displacement: 249cc
Displacement: 249cc
Maximum output: 40ps/9,500 rpm
Maximum torque: 3.5kg-m/8,000 rpm
Dry weight: 134kg
Engine type: Air-cooled 2-stroke V-type,
 2 case lead valves
Overall length: 1,965mm
Overall height: 1,095mm
Overall width: 685mm
Seat height: 765mm
First released: 1996

An air intake raising the fuel efficiency.

In the past, American-style bikes produced in Japan didn't look so good because manufactures dared not to make bikes similar to the Harley-Davidson. But this Vulcan is a true American, and it closely resembles a Harley. If you really want to match a Harley, there is also the Vulcan 1,300cc. Even without customization it looks great. Still, this bike is just begging to be customized. You can change the handlebars, muffler, seat and fender to make your own personal chopper.

The tank and seat are wide.

The meters and gauges rest on top of the tank, resembling those of a Harley. This is unusual for an American-style bike produced in Japan.

The Vulcan II is equipped with flat-type handlebars.

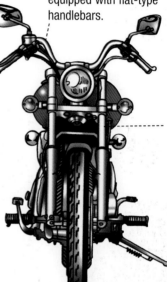

The first Japanese-produced produced wide-grand fork. The pitch of the left and right front fork is wide and has power. The pitch is almost the same as that of a Harley, 240 millimeters.

This is Kawasaki's American-style seat, based on a design that's been a favorite in the United States for years. The surface is made of a plush super-urethane. In the finest tradition of the American "Iron Horse," this bike is built more for long-haul comfort than speed.

Point

When coloring an illustration of a motorcycle, be creative with your choices for the tank and fenders. Other metal parts should be shiny. On American bikes, the use of metal parts is extensive, so steel colors are essential.

Rear tire size is 140/90-16, one size wider than that of a Harley.

Unfortunately, the sound is comparatively quiet. It doesn't have the throaty rumble of a Harley.

Name: Vulcan
Maker: Kawasaki
Displacement: 399cc
Maximum output: 33ps/8,500 rpm
Maximum torque: 3.3kg-m/4,500 rpm
Dry weight: 223kg
Engine type: Water-cooled 4-stroke, V-type 2-cylinder SOHC 4-valve
Overall length: 2,360mm
Overall height: 1,175mm
Overall width: 835mm
Seat height: 710mm
First released: 1995

Spokes typify the cool style of American bikes.

The front tire size is 80/90-21.

Two cut-mufflers on the left side. The thinner and straight-type mufflers are also attractive.

The V-type engine is standard for American-style motorcycles.

TOSHO PANDORA TS1

Retro-style scooters have been all the rage in Japan in recent years. Many unique scooter designs were released in the 1960s, and today's models mimic those chic styles. Among the more popular contemporary scooters with old-school flair are the Rapid, the Silver Pigeon and this Pandora. Why not have the hero of heroine of your manga scoot about town on one of these? Be sure to use retro color schemes as well.

The handlebar and headlight are a single unit, a safety feature that was unusual at the time the Pandora was first released but common today.

The Pandora was the first 125cc scooter to come equipped with a front brake. (The initial self-starting Dynamo was also equipped with this.)

Name: Tosho Pandora TS1
Maker: Tosho Automobiles, Ltd.
Displacement: 123cc
Maximum output: 6.5HP/5,200 rpm
Maximum torque: 1.03kg-m/4,000 rpm
Dry weight: 120kg
Engine type: Compressed air-cooled 2-stroke single-cylinder
Overall length: 1,850mm
Overall height: 950mm
Overall width: 780mm
First released: 1959

Very long back mirror.

The seat is meant for one rider.

It is not necessary to raise the seat cover to get to the oil port, which is conveniently located behind the seat.

From here, the frame moves back and opens up to reveal the engine.

The tail fins are a distinguishing characteristic of the Pandora.

Name: Falcorustyco
Maker: Suzuki
Engine Type: Liquid-cooled 4 square-four DOHC 16 valve engine

The front and back forks and the front brake are electronically controlled. The rear brake is also hydraulic.

FALCORUSTYCO

Suzuki exhibited this concept bike at the 26th Tokyo Motor Show back in 1986. The futuristic design delighted motorcycle enthusiasts and hinted at what we may someday be riding. The most unusual and intriguing aspect of the design is the near-absence of user-operated parts. Beyond the handlebars, levers and start pedal, there isn't much else for the rider to worry about. It makes you wonder how it can be operated. Bikes resembling this prototype have appeared in recent movies and anime series. Perhaps the real thing is just around the corner.

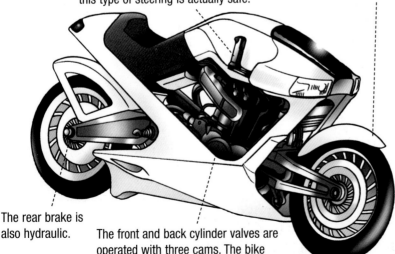

Gun grip handle. It's debatable whether this type of steering is actually safe.

The rear brake is also hydraulic.

The front and back cylinder valves are operated with three cams. The bike features fuel-injection and sophisticated hydraulics.

To ensure its position among the world's top motorcycles, the TDM850 underwent an exterior makeover while retaining its overall rugged good looks. The single headlight was fitted with a projector, the horsepower and torque were beefed up, and the bike was then mass-produced, making it the pride of Yamaha. The frame is delta box and the engine leans forward like Genesis. (Previous sentence needs to be clarified.) There weren't any significant changes from the 5-valve type but the excellence of its lineage makes it difficult to complain about its street-riding, rough-terrain handling, or high-speed performance. The position doesn't tire the rider and the baggage capacity isn't bad. Because of its off-road base, the lower back is at a slightly high position, and compared to the initial model the weight has increased but the pleasure this bike will give you hasn't changed a bit. Regardless of the generation, this bike continues to be held in high esteem. The TDM850 is often referred to as a horse, which makes the battle scene involving a real horse and an off-road version of this bike in "True Lies" all the more interesting.

The front fork, with its high center of gravity, is vertical, allowing for quick turning.

Has an exhaust greater than that of two 400cc (mid-sized) bikes. Talk about powerful!

Name: TDM850
Maker: Yamaha
Displacement: 849cc
Maximum output: 80ps/7,500 rpm
Maximum torque: 8.2kg-m/6,000 rpm
Dry weight: 203kg
Engine type: Water-cooled 4-stroke 2-cylinder DOHC 10-valve
Overall length: 2,165mm
Overall height: 1,280mm
Overall width: 790mm
Seat height: 795mm
First released: 1997

Rear cowl, with good load carrying capacity, and hook.

The front mask is designed to resemble a hawk.

149mm long-stroke front fork.

Powerful phase 270-degree parallel twin. It appropriates the engine of the racer replica XTZ750, the model shown at the Paris-Dakar Rally.

Yamaha's data states that its top speed is 202km/h but the export version has a speedometer that goes up to 230km/h. I wonder what that is all about.

A comfortable two-seater.

Released in North America and Europe in 1978 to much acclaim. Unlike today, when importing is common, the initial release of this bike was very unusual. It wasn't commonly seen on the streets, and when I first saw it at a motor show I was impressed. It's a bike with tremendous power.

Honda released this 6-cylinder motorcycle way back in 1978. The model is often compared with the 6-cylinder Z1300, released by Kawasaki at the same, but it's safe to say the only similarity seems to be that they both have the same number of cylinders. For the six cylinders are six aligned carburetors. It is a chain-driven, air-cooled chain drive, air-cooled 4-valve machine, and 50 kilograms lighter than the Kawasaki. On top of all this, the difference in design is apparent. It may not be as reliable as the Super Sports bike CBX1000, and the 35mm front inner tube and front/rear tires of 3.50H19/4.25H18 aren't all that reliable, taking into consideration its power output and weight. However, what is important to note here is that the bike doesn't compare unfavorably with newer models. The engine's oscillation is minimal and revolution is smooth. In other words, it doesn't feel like a bike that was made over 20 years ago. It's character hasn't diminished with age but has, in fact, grown.

The engine is so large it sticks out at the sides. Pure power! The mechanics and construction of this machine are absolutely amazing.

Name: CBX1000
Maker: Honda
Displacement: 1,047cc
Maximum Output: 103ps/9,000 rpm

The muffler is assembled into three rods. The form-fitting design of the mufflers in this area is beautiful.

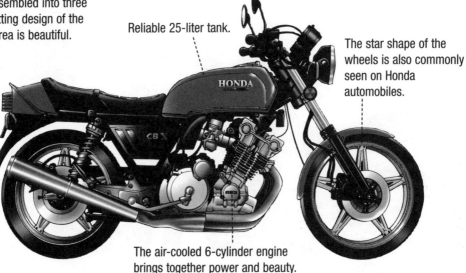

Reliable 25-liter tank.

The star shape of the wheels is also commonly seen on Honda automobiles.

The air-cooled 6-cylinder engine brings together power and beauty.

The muffler produces a velvet-smooth sound.

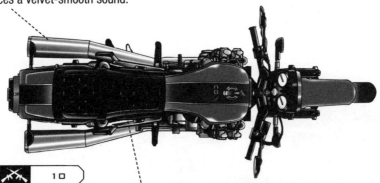

The seat is more functional than visual.

MILITARY

The prototype P-51A, which made its first flight in October 1940, was considered a masterpiece of engineering. It was initially produced for the British to provide long-range bomber support, but the Army Air Forces also eventually decided to use it. In 1944 the AAF introduced the P-51D, an aircraft with which Germany and Japan simply could not contend. The B-29s that conducted the decisive bombing missions across Japan during the final year of the war were escorted by P-51s.

The U.S. Army Air Forces served both the Army and the Navy during World War II. (The modern U.S. Air Force was established until 1947.) Among the aircraft used by the AAF were many fighters, including the P-51, which was nicknamed the "Mustang."

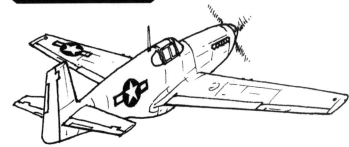

P-51B

P-51D Pilot's Seat

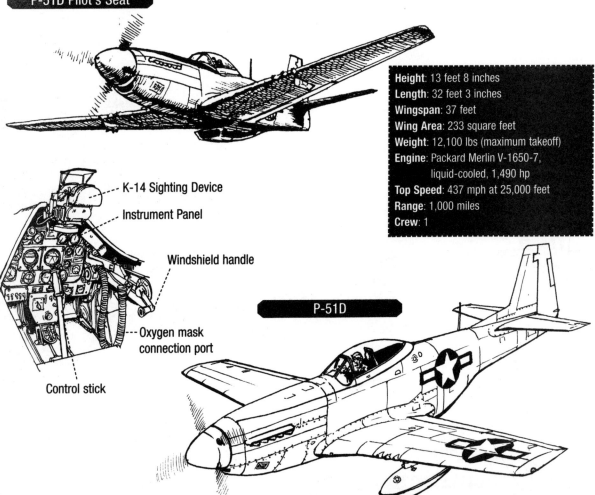

K-14 Sighting Device

Instrument Panel

Windshield handle

Oxygen mask connection port

Control stick

Height: 13 feet 8 inches
Length: 32 feet 3 inches
Wingspan: 37 feet
Wing Area: 233 square feet
Weight: 12,100 lbs (maximum takeoff)
Engine: Packard Merlin V-1650-7, liquid-cooled, 1,490 hp
Top Speed: 437 mph at 25,000 feet
Range: 1,000 miles
Crew: 1

P-51D

The Mustang was significantly improved with the introduction of the British-designed and U.S.-assembled Packard V-1650 series "Merlin" engine in the P-51B. This new version of the fighter was easier to control and exhibited overall superior performance compared to the German aircraft it was designed to counter.

Height: 13 feet 6 inches
Length: 33 feet 7 inches
Wingspan: 42 feet 10 inches
Wing Area: 334 square feet
Weight: 15,413 lbs (maximum takeoff)
Engine: Pratt & Whitney R-2800-10W, air-cooled, 2,000 hp
Top Speed: 380 mph at 23,400 feet
Range: 1,530 miles (maximum)
Crew: 1
Armament: Six .50-caliber machine guns, two 1,000-pound bombs

Arrester hook

F6F-5

Often referred to as the "Zero Killer" for its overwhelming success against Japanese aircraft, the Grumman F6F-5 "Hellcat" was the most effective carrier-based fighter of World War II.

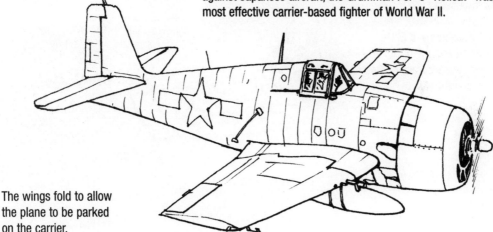

The wings fold to allow the plane to be parked on the carrier.

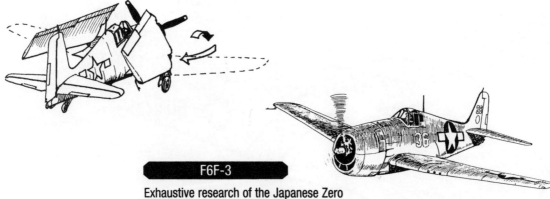

F6F-3

Exhaustive research of the Japanese Zero by the Allies led to the development of the F6F-5, which overpowered its enemy. By war's end, the Hellcat had a kill radio of 19-to-1.

Height: 14 feet 9 inches
Length: 37 feet 6.5 inches
Wingspan: 39 feet 1.4 inches
Wing Area: 313.4 square feet
Weight: 17,797 lbs (maximum takeoff)
Engine: General Electric J47-GE-27,
5,910-pound thrust
Top Speed: 678 mph at sea level
Range: 1,525 miles (maximum)
Crew: 1
Armament: Six .50-caliber machine guns,
two 1,000-pound bombs (or 16
rockets)

U.S. AIR FORCE (1947)
NORTH AMERICAN F-86F SABRE

The Sabre was the only U.S. aircraft that could contend with the Soviet MiG-15, and was the first plane to fly faster than a MiG. During the Korean War, Sabres and MiGs were so equally matched that the deciding factors for victory were the accuracy of the radar-sighting device and the skill of the pilot.

Until World War II, U.S. development of jet fighters lagged behind that of Germany and England. As a consequence, the United States was not able to engage in air combat at the outset of the war. The lesson was learned, however, and jet fighter development continued following the war. (Upon the establishment of the Air Force in 1947, aircraft designations that began with a "P," for "pursuit," were changed to "F," as in "fighter.")

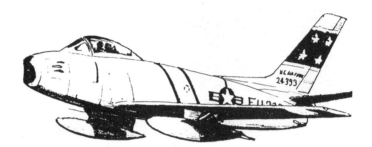

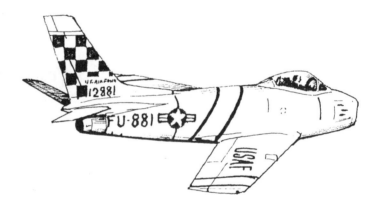

These markings (consisting of a wide yellow band with thin black borders) on the fuselage and wings of the aircraft help pilots distinguish allied aircraft from those of the enemy.

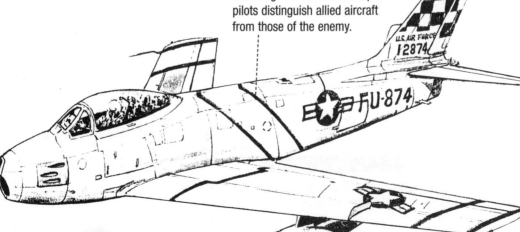

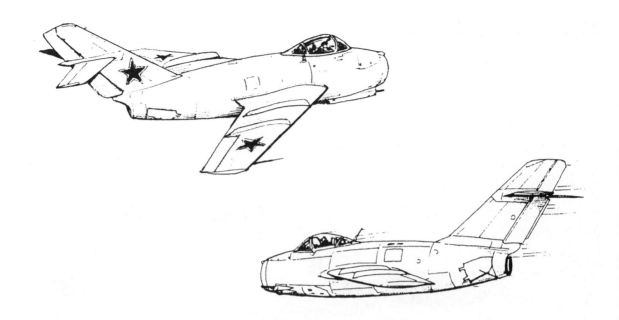

MIKOYAN MiG-15 FAGOT

This MiG was the flagship aircraft of air forces throughout the Communist bloc for nearly 15 years, beginning in 1949. Indeed, the Fagot was the most highly respected interceptor plane of the 1950s. Its capacity at high altitudes and ascension power were better than the Sabre, and its overall outstanding performance is what made MiG a household name in the aviation industry, With the appearance of this plane over Korean airspace on November 1, 1950, the U.S. military didn't have a plane that could match it, so the F-86 was hastened into battle.

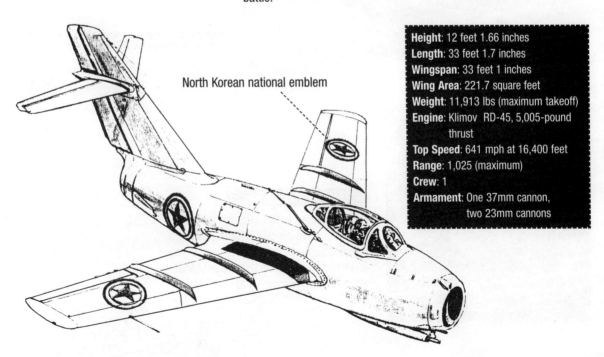

North Korean national emblem

Height: 12 feet 1.66 inches
Length: 33 feet 1.7 inches
Wingspan: 33 feet 1 inches
Wing Area: 221.7 square feet
Weight: 11,913 lbs (maximum takeoff)
Engine: Klimov RD-45, 5,005-pound thrust
Top Speed: 641 mph at 16,400 feet
Range: 1,025 (maximum)
Crew: 1
Armament: One 37mm cannon, two 23mm cannons

U.S. and Soviet jet fighters, which first did battle during the Korean War, squared off again during the Vietnam War. The aircraft introduced in this section were also used by Britain, West Germany, Japan, the two Koreas and the Warsaw Pact nations. In fact, many of the aircraft are still being used. The American and Soviet fighters introduced here were also used by Britain, West Germany, Japan, Korea and East Europe. Many of them are still being used.

United States (1958)
McDonnell Douglas F-4 Phantom II

This multi-role fighter, developed to be a carrier-based plane, was used for land (and sea) attacks, bombing and reconnaissance, It was soon the primary aircraft of both the Air Force and Navy.

U.S. Navy F-4C

From 1960 to 1980, this was the main fighter for air forces of Western countries.

U.S. Air Force F-4D

Japan Air Self-Defense Force F-4EJ

Height: 16 feet 3 inches
Length: 58 feet 3.75 inches
Wingspan: 38 feet 4.75 inches
Wing Area: 530 square feet
Weight: 54,800 lbs (maximum takeoff)
Engines: General Electric J79-GE-8 (two), 8.1-ton thrust
Top Speed: Mach 2.2 to 2.4 at 45,000 feet
Range: 1,800 miles (combat)
Crew: 2
Armaments: One 20mm Vulcan cannon, eight air-to-air missiles or 16,000-pound payload

U.S. Air Force F-4E

As was learned in Vietnam, armament limited to air-to-air missiles put pilots at a severe disadvantage, so the Air Force began equipping the F-4 with the powerful M61 20mm Vulcan cannon, which held 640 rounds.

20mm Vulcan Cannon

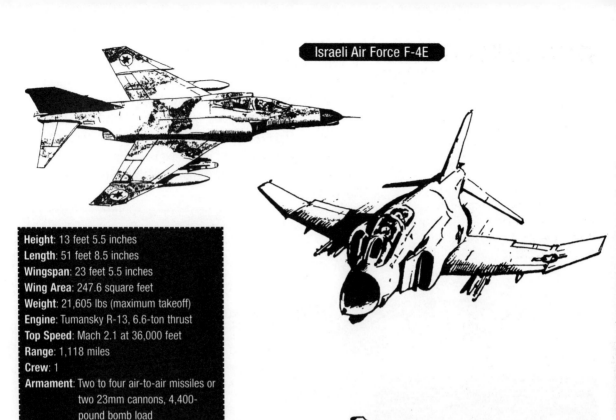

Height: 13 feet 5.5 inches
Length: 51 feet 8.5 inches
Wingspan: 23 feet 5.5 inches
Wing Area: 247.6 square feet
Weight: 21,605 lbs (maximum takeoff)
Engine: Tumansky R-13, 6.6-ton thrust
Top Speed: Mach 2.1 at 36,000 feet
Range: 1,118 miles
Crew: 1
Armament: Two to four air-to-air missiles or two 23mm cannons, 4,400-pound bomb load

SOVIET ARMY (1959)
MIKOYAN MiG-21 FISHBED

The Fishbed is the representative Mach 2-class Soviet pursuit fighter. With its excellent maneuverability, this MiG is still highly favored and in use by more than 30 East European countries. More than 15,000 of these planes have been built, making it the most extensively produced aircraft of its kind and the one with the longest life span.

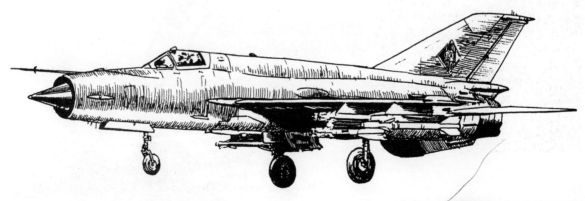

UNITED STATES (1979)
McDONNELL DOUGLAS F-15C EAGLE

In June 1982, following the attempted assassination of the Israeli ambassador in London, Israel began attacking targets above the Lebanese-Syrian border between Israel and Syria. Thus began the Lebanon War, a conflict in which Israeli pilots flying F-15s and F-16s would shoot down 70 Syrian planes without losing a single aircraft of their own. These air battles demonstrated to the world just how far the American-built F-series had evolved.

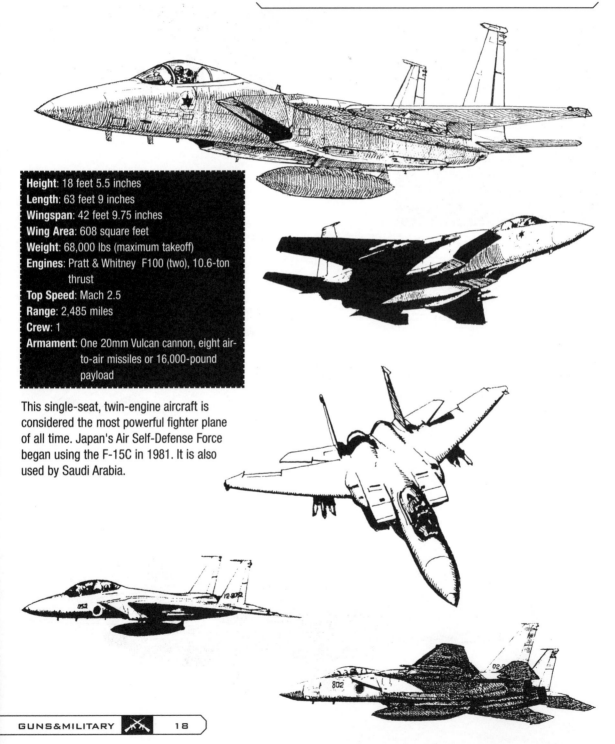

Height: 18 feet 5.5 inches
Length: 63 feet 9 inches
Wingspan: 42 feet 9.75 inches
Wing Area: 608 square feet
Weight: 68,000 lbs (maximum takeoff)
Engines: Pratt & Whitney F100 (two), 10.6-ton thrust
Top Speed: Mach 2.5
Range: 2,485 miles
Crew: 1
Armament: One 20mm Vulcan cannon, eight air-to-air missiles or 16,000-pound payload

This single-seat, twin-engine aircraft is considered the most powerful fighter plane of all time. Japan's Air Self-Defense Force began using the F-15C in 1981. It is also used by Saudi Arabia.

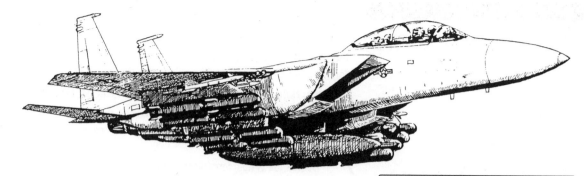

UNITED STATES (1986)
F-15E STRIKE EAGLE

The assault plane version of the Eagle. Seats two and has a bomb payload of 24,500 pounds.

UNITED STATES (1974)
GENERAL DYNAMICS F-16 FIGHTING FALCON

Height: 16 feet 5.2 inches
Length: 49 feet 4 inches
Wingspan: 32 feet 9.75 inches
Wing Area: 300 square feet
Weight: 33,000 lbs (maximum takeoff)
Top Speed: Mach 2
Range: 3,700km
Crew: 1
Armament: One 20mm Vulcan cannon, six air-to-air missiles or 16,000-pound payload

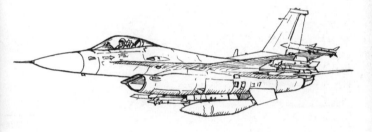

Developed as a lightweight fighter to support the F-15. Though it's a small and light single-engine fighter, it is capable of carrying large amounts of weapons and is used for several purposes. In addition to the United States, the F-16 is used by Israel, South Korea, Taiwan, Holland and several other nations. Japan's next-generation auxiliary fighter F-2 is based on the F-16.

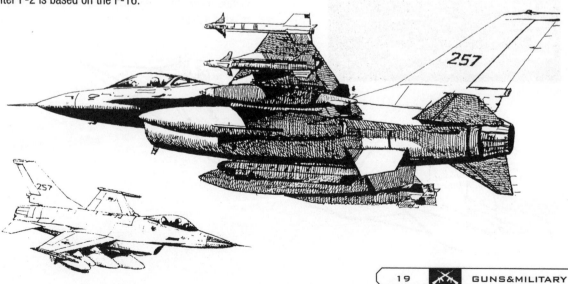

Supersonic planes until now have used afterburners for increasing thrust to surpass the speed of sound. However, because this process consumes a lot of fuel, it is only possible for the aircraft to maintain supersonic speed for just a few minutes. Here we introduce the aircraft that will become the main fighter planes of the 21st century.

Double tail wings, forming 27-degree angles.

Exterior of the smallest radar reflector

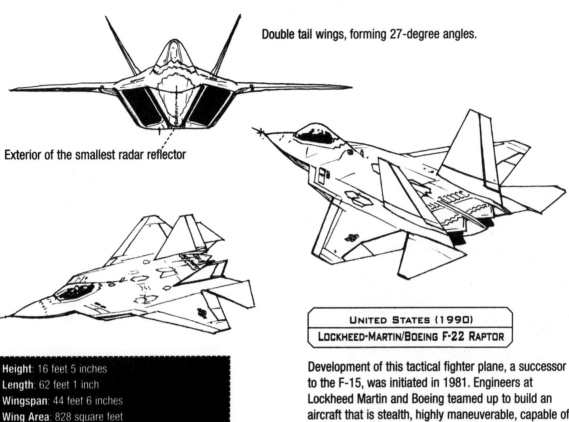

UNITED STATES (1990)
LOCKHEED-MARTIN/BOEING F-22 RAPTOR

Height: 16 feet 5 inches
Length: 62 feet 1 inch
Wingspan: 44 feet 6 inches
Wing Area: 828 square feet
Weight: 840 square feet
Engines: Pratt & Whitney F119 (two),
　　　　　15.9-ton thrust
Top Speed: Mach 1.8
Range: 3,000 km
Crew: 1
Armament: One 20mm Vulcan cannon,
　　　　　eight air-to-air missiles

Development of this tactical fighter plane, a successor to the F-15, was initiated in 1981. Engineers at Lockheed Martin and Boeing teamed up to build an aircraft that is stealth, highly maneuverable, capable of supersonic cruising—and deadly. The Raptor cruises at supersonic speeds at mid-level altitudes, evades anti-aircraft fire and closes in on enemy aircraft almost without effort. Its flying range and overall efficiency make it a plane high in demand.

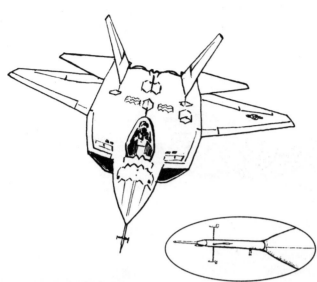

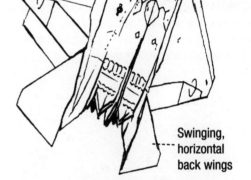

Side bays for air-to-air (AAM) missiles

Cranked-arrow main wings

Underside missile bay (mid-range AAM)

Swinging, horizontal back wings

High-visibility Cockpit

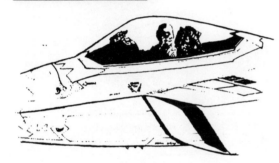

Adjustable, vector thrust nozzles

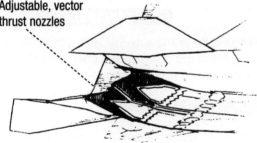

Front Wheel

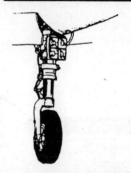

Main Wheel

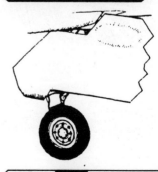

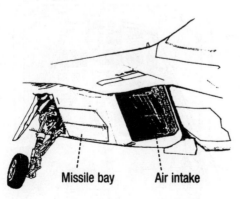

Missile bay Air intake

Here we introduce the representative fighter planes of WWII Germany. At the start of the war, Messerschmitt boasted its power in Europe's skies.

GERMANY (1935)
MESSERSCHMITT Bf109

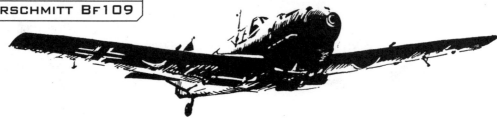

The Bf 109 was the main fighter class of the German air force (Luftwaffe). The best known of these are the model E (short for Emil), model F (Friedrich) and model G (Gustav). In the Battle of Britain, the Bf 109 played out a series dramatic air battles with the British Spitfire. The German aircraft was continually improved throughout the war and continued to play a major role until the war's end. More than 33,000 of each model were built, making it the most produced fighter in the world at the time.

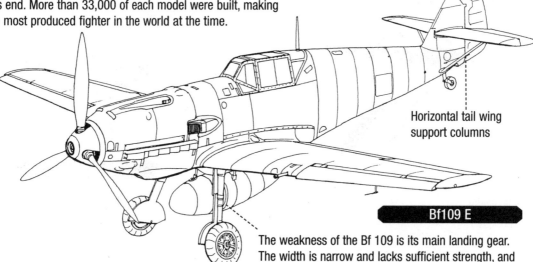

Horizontal tail wing support columns

Bf109 E

The weakness of the Bf 109 is its main landing gear. The width is narrow and lacks sufficient strength, and accidents upon landing were common.

Canopy

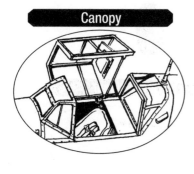

Cockpit

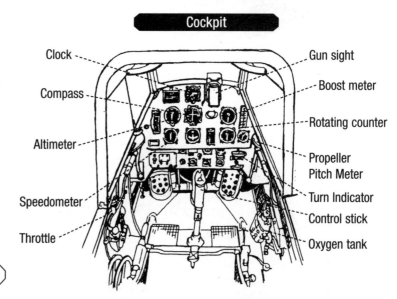

Clock

Compass

Altimeter

Speedometer

Throttle

Gun sight

Boost meter

Rotating counter

Propeller Pitch Meter

Turn Indicator

Control stick

Oxygen tank

DB601A Engine (1,020hp)

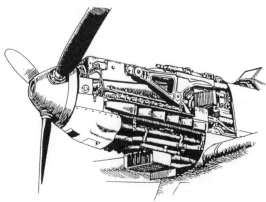

Height: 8 feet 6 inches
Length: 28 feet 8 inches
Wingspan: 32 feet 6.5 inches
Wing Area: 174 square feet
Weight: 7,500 lbs (maximum takeoff)
Engine: Daimler-Benz DB605A-1, liquid-cooled,
　　　　1,475 hp
Top Speed: 387 mph
Range: 425 miles
Crew: 1
Armament: Three 20mm cannons, two 13mm guns

7.92mm gun

Bf109 G-F

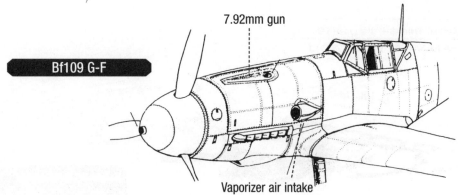

Vaporizer air intake

Bf109 G

This aircraft first took flight in July 1941. With its sophisticated nose design, this type had the best balance among the Bf109 series and was favored by ace pilots.

The G series was introduced in 1942.

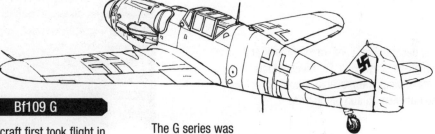

The gun on the outside of the plane head was enhanced to 13mm so there is a bulge.

Bf109 G-6

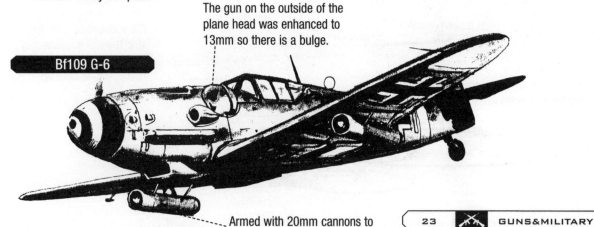

Armed with 20mm cannons to pursue bomber planes.

West Germany, Great Britain and Italy jointly and simultaneously developed the following four aircraft to meet each country's individual requirements:

British Air Force: Fighter Interceptor (ADV)
British Navy: Carrier Assault Plane (IDS)
German Air Force: Fighter Plane (ADV)
Italy: Battle & Bomber Plane (IDS)
Electronic Combat & Reconnaissance (ECR) planes were also developed.
During the Gulf War, ultra-low-altitude assault planes were used and, surprisingly, losses were great: 8 planes.

GERMAN, BRITISH, ITALIAN(1974)
PANAVIA TORNADO

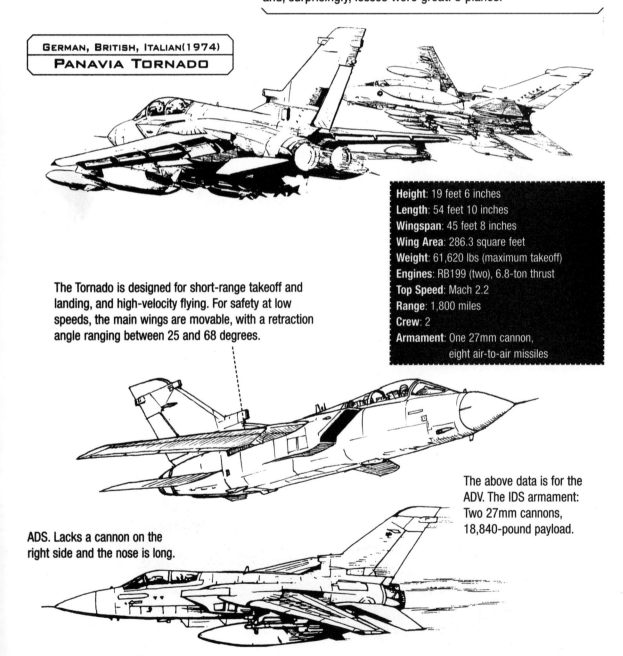

The Tornado is designed for short-range takeoff and landing, and high-velocity flying. For safety at low speeds, the main wings are movable, with a retraction angle ranging between 25 and 68 degrees.

Height: 19 feet 6 inches
Length: 54 feet 10 inches
Wingspan: 45 feet 8 inches
Wing Area: 286.3 square feet
Weight: 61,620 lbs (maximum takeoff)
Engines: RB199 (two), 6.8-ton thrust
Top Speed: Mach 2.2
Range: 1,800 miles
Crew: 2
Armament: One 27mm cannon, eight air-to-air missiles

The above data is for the ADV. The IDS armament: Two 27mm cannons, 18,840-pound payload.

ADS. Lacks a cannon on the right side and the nose is long.

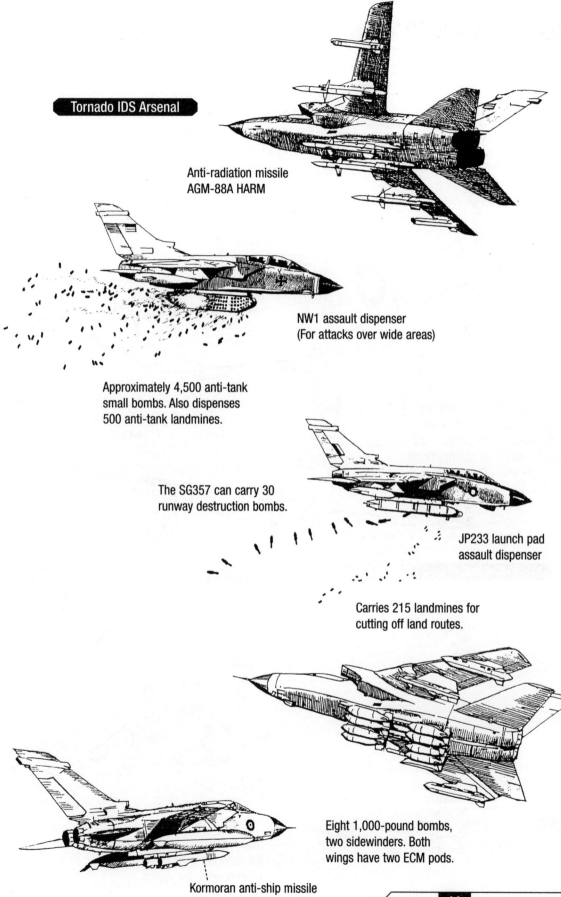

Tornado IDS Arsenal

Anti-radiation missile
AGM-88A HARM

NW1 assault dispenser
(For attacks over wide areas)

Approximately 4,500 anti-tank
small bombs. Also dispenses
500 anti-tank landmines.

The SG357 can carry 30
runway destruction bombs.

JP233 launch pad
assault dispenser

Carries 215 landmines for
cutting off land routes.

Eight 1,000-pound bombs,
two sidewinders. Both
wings have two ECM pods.

Kormoran anti-ship missile

During the 1940 Battle of Britain, the Spitfire persevered against the fierce attack of the Luftwaffe, always holding its own against the Bf 109. Indeed, the Spitfire was faster, maneuvered better and was able to ascend and descend more gracefully than the German aircraft. Beginning in 1943, Spitfire pilots saw action in the Far East, where they battled Japanese Zero and Hayabusa fighters. In all, 22,521 Spitfire series aircraft were built during the war, a number that was second only to Bf 109 production.

BRITAIN (1936)
SUPERMARINE SPITFIRE

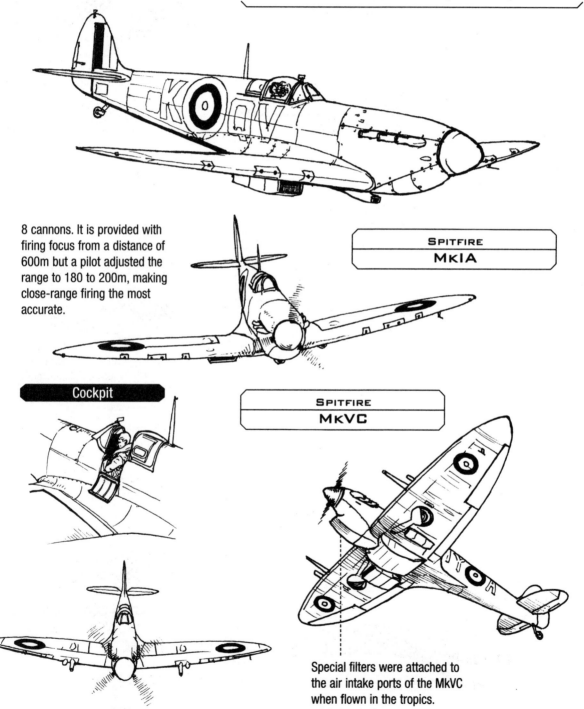

8 cannons. It is provided with firing focus from a distance of 600m but a pilot adjusted the range to 180 to 200m, making close-range firing the most accurate.

SPITFIRE
MKIA

Cockpit

SPITFIRE
MkVC

Special filters were attached to the air intake ports of the MkVC when flown in the tropics.

A Type
Four 7.7mm

B Type
One 20mm

C Type
It can have armaments equivalent to either the A or B type and can carry one bomb.

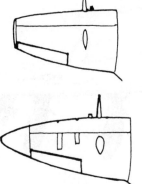

E Type
One 20mm
Two 7.7mm
The wing was clipped to enhance maneuvering at low altitudes.

H/F Type
For high-altitude flights the wing's tip is extended.

Height: 11 feet 5 inches
Length: 29 feet 11 inches
Wingspan: 36 feet 10 inches
Wing Area: 242 square feet
Weight: 6,400 pounds (maximum takeoff)
Engine: Rolls-Royce Merlin 45, liquid-cooled
 1,440 hp
Top Speed: 374 mph
Range: 470 miles
Crew: 1
Armament: Two 20mm cannons,
 four 7.7mm guns,
 one 500-pound bomb

Assault

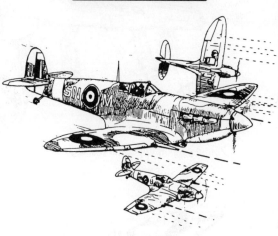

The representative Spitfire was completed in March 1941.

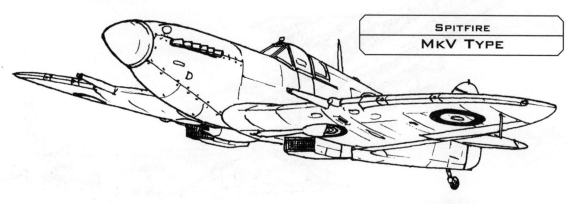

SPITFIRE
MkV TYPE

UNITED STATES-BRITAIN (1978)
McDONNELL DOUGLAS/BAe AV-8B HARRIER II

Height: 11 feet 7.75 inches
Length: 46 feet 4 inches
Wingspan: 30 feet 4 inches
Wing Area: 230 square feet
Weight: 31,000 lbs (maximum short takeoff);
　　　　　18,900 lbs (maximum vertical takeoff)
Engine: Rolls-Royce Pegasus 11, 9.7-ton thrust
Top Speed: Mach 1
Range: 1,700 miles
Crew: 1
Armament: One 25mm cannon,
　　　　　9,200-pound payload

Jointly developed by England and America, this carrier-based assault plane can both vertically takeoff and land on a carrier. In 1960, England developed the first V/STOL (Vertical and/or Short Take-Off Landing) plane, the Harrier. To support landing operations, the US army requested the Harrier be improved as a VTOL fighter plane. McDonnell Douglas and BAe developed the AV-8B together. Compared to the prototype, the arsenal capacity and flying range was greatly increased. The scene where this plane is flown in the movie "True Lies" is still fresh in my memory.

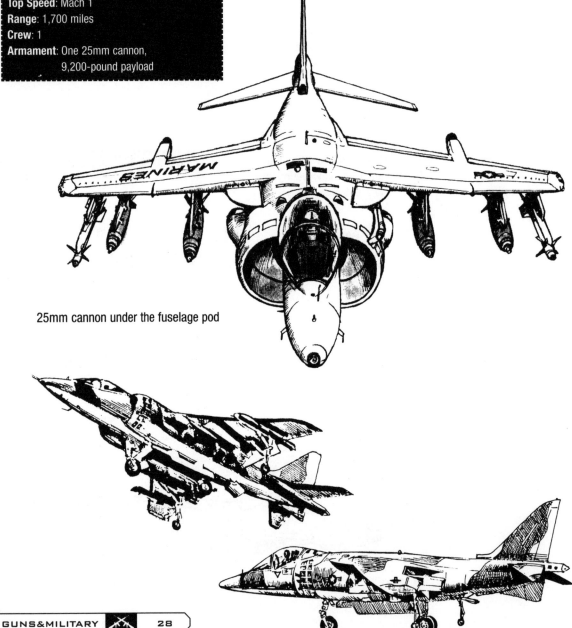

25mm cannon under the fuselage pod

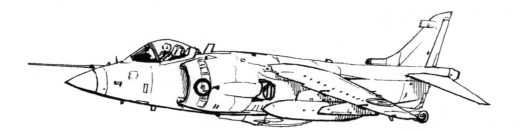

It was the carrier-based fighter plane used by England in the Falklands War. The AV-8B was used by the English air force as a GR-5 Harrier. This was improved to be the Sea Harrier.

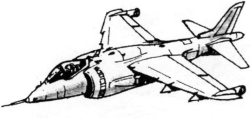

AV-8A Harrier (GR-1)
The world's first VTOL aircraft

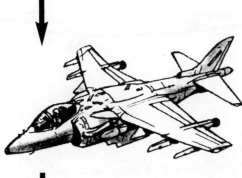

AV-8B Harrier II
It has twice the capability of the first.

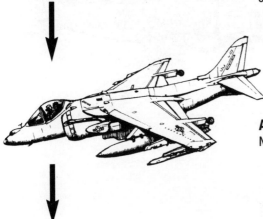

AV-8B (NA)
Night attack plane

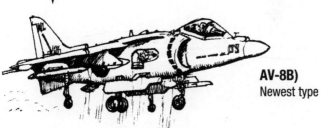

AV-8B)
Newest type

ITALY (1937)
MACCHI MC-200 SAETTA FIGHTER

Italy used the MC-200 Saetta ("Lightning") throughout the first half of World War II. Though it maneuvered quite well, its armaments were weak, and the plane quite simply overmatched in combat over the Mediterranean, North Africa, Greece and the Soviet Union. With the introduction of the MC-202, the Saetta was used primarily for bombing missions.

Release-type Canopy

Height: 10 feet
Length: 27 feet 6 inches
Wingspan: 34 feet 8 inches
Wing Area: 181 square feet
Weight: 5,275 (maximum takeoff)
Engine: Fiat A-74, air-cooled 870 hp
Top Speed: 313 mph
Range: 355 miles
Crew: 1
Armament: Two 12.7mm guns,
two 352-pound bombs

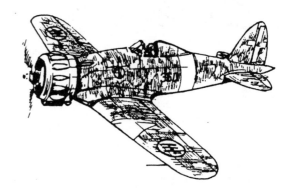

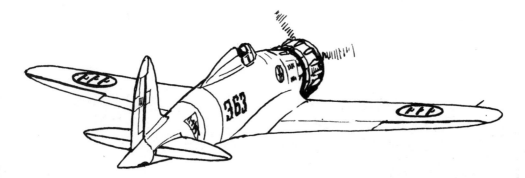

ITALY (1940)
MACCHI MC-202 FOLGORE

The Folgore ("Thunderbolt") is considered
the finest Italian fighter of the war, and
proved itself to be more effective than the
Hawker Hurricane and the P40 in dogfights
over North Africa.

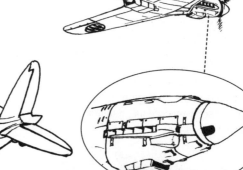

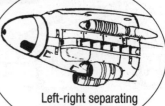

MC-202
DB601 engine

Height: 9 feet 11.5 inches
Length: 29 feet 0.5 inches
Wingspan: 34 feet 8.5 inches
Wing Area: 180.8 square feet
Weight: 6,768 lbs (maximum takeoff)
Engine: Alpha Romeo RA1000, RC-41
 (DB601 domestically produced),
 1,175 hp
Top Speed: 372 mph at 18,370 feet
Range: 475 miles
Crew: 1
Armament: Two 12.7mm guns, two 7.7mm
 guns, two 352-pound bombs

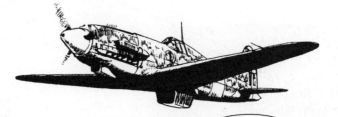

ITALY (1942)
MACCHI MC-205 VELTRO ("GREYHOUND")

New version of the Folgore. Apart from the
engine and the addition of a 20mm cannon,
it is almost identical to the MC-202.

MC-205
DB605A-1 engine

Left-right separating
oil cooler

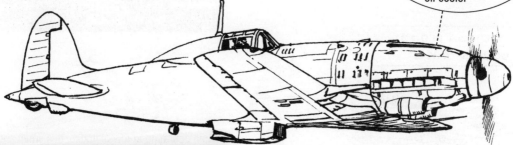

Engine: Fiat RA105RC58
 (DB605A-1 domestically produced)
Top Speed: 398 mph at 23,616 feet
Range: 646 miles
Armament: Two 20mm cannons, two 12.7mm guns

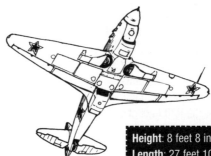

SOVIET UNION (1940)
YAKOVLEV YAK-1

At the start of the war, the YaK-1 was the Soviet Union's principal fighter. The outside panels of the fuselage were wooden and semi-monocoque. It fought well against the Bf 109.

Height: 8 feet 8 inches
Length: 27 feet 10 inches
Wingspan: 32 feet 9 inches
Wing Area: 184.61 square feet
Weight: 6,276 lbs (maximum takeoff)
Engine: Klimov M-105PF, liquid-cooled, 1,100 hp
Top Speed: 373 mph at 9,845 feet
Range: 435 miles
Crew: 1
Armament: One 20mm cannon, two 7.62mm guns

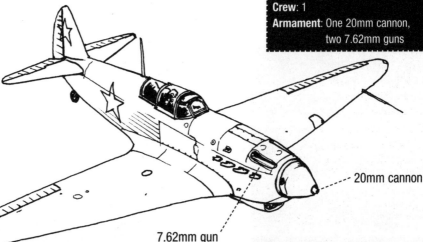

20mm cannon

7.62mm gun

Skis for Landing on Snow

Height: 7 feet 11 inches
Length: 27 feet 10 inches
Wingspan: 30 feet 2 inches
Wing Area: 159.3 square feet
Weight: 5,864 lbs (maximum takeoff)
Engine: Klimov M105PF-2, liquid-cooled, 1,260 hp
Top Speed: 407 mph at 14,750 feet
Range: 559 miles
Crew: 1
Armament: One 20mm cannon, two 12.7mm guns

SOVIET UNION (1943)
YAKOVLEV YAK-3

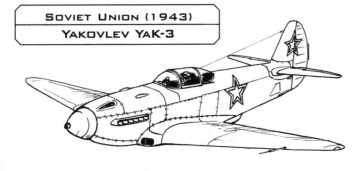

When operating at low altitudes, this small and lightweight fighter performed particularly well against Germany's more powerful Bf 109 and Fw190 aircraft. The YaK-3 was also used for ground assaults. Though the number "3" suggests otherwise, this model was actually introduced after the YaK-9.

SOVIET UNION (1942)
YAKOVLEV YAK-9

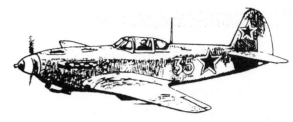

The Yak-9 was the principal Soviet fighter in the second half of the war. A few of these planes were also used in the Korean War.

Height: 9 feet 8 inches
Length: 29 feet 0.5 inches
Wingspan: 32 feet 0.75 inches
Wing Area: 177.6 square feet
Weight: 6,830 lbs (maximum takeoff)
Engine: Klimov M105PF, liquid-cooled,
 1,210hp
Top Speed: 434 mph at 16,405 feet
Range: 541 miles
Crew: 1
Armament: One 20mm cannon,
 one 12.7mm gun

SOVIET UNION (1944)
LAVOCHKIN LA-7

Height: 9 feet 3 inches
Length: 27 feet 7 inches
Wingspan: 32 feet 2 inches
Wing Area: 188 square feet
Weight: 7,496 lbs (maximum takeoff)
Engine: Shvetsov AM-82FN, air-cooled, 1,775hp
Top Speed: 423 mph
Range: 615 miles
Crew: 1
Armament: Three 20mm cannons,
 one 660-pound bomb

Along with the YaK-9, the La-7 was used extensively by the Soviets during the second half of the war. With a body made of wood, the plane handled well at low altitudes, and several ace pilots flew it.

Pitot tube
(used on aircraft as speedometers)

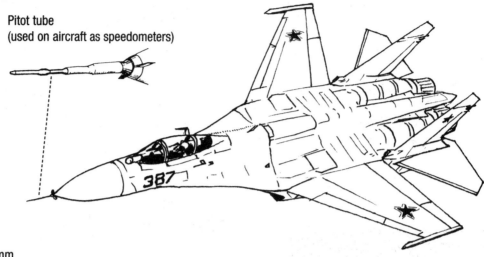

Gsh-301 30mm
cannon

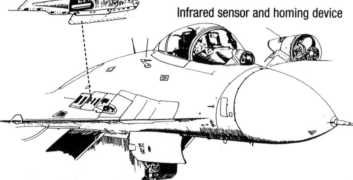

Infrared sensor and homing device

SOVIET UNION (1981)
SUKHOI SU-2 FLANKER

As successor to the MiG-29, the Su-27 represents a new generation of larger, more powerful Soviet pursuit planes. In addition to its considerable strength, it also features a radar system that is as advanced as those found on U.S. aircraft. The gun is controlled via "fly-by-wire" (FBW), a control system in which pilots' inputs are transmitted to control surfaces electronically or through fiber optics rather than by mechanical linkage.

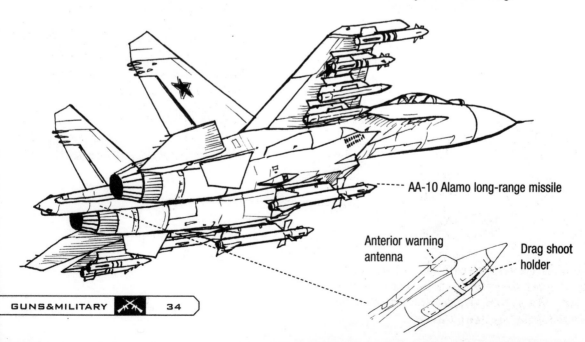

AA-10 Alamo long-range missile

Anterior warning
antenna

Drag shoot
holder

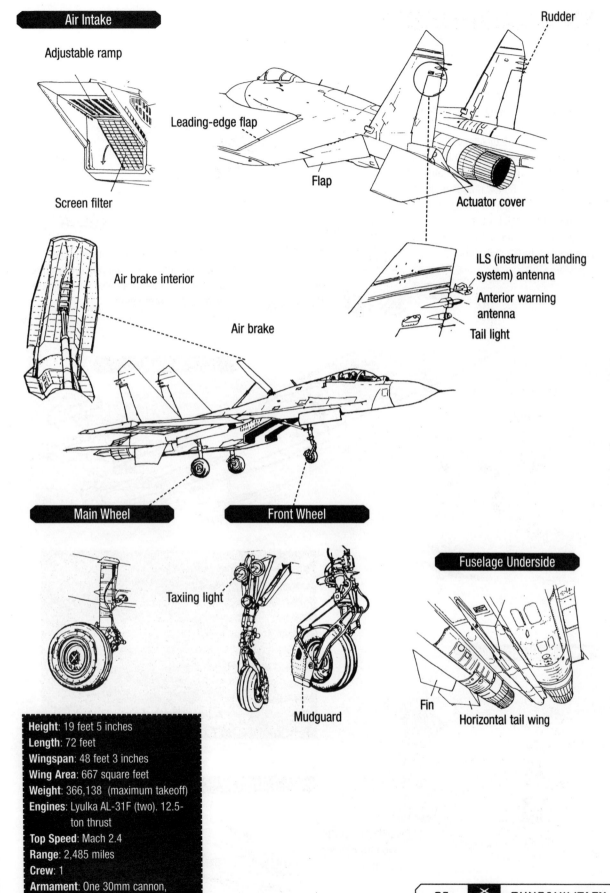

Adjustable ramp

Screen filter

Rudder

Leading-edge flap

Flap

Actuator cover

Air brake interior

Air brake

ILS (instrument landing system) antenna

Anterior warning antenna

Tail light

Main Wheel

Front Wheel

Taxiing light

Mudguard

Fuselage Underside

Fin

Horizontal tail wing

Height: 19 feet 5 inches
Length: 72 feet
Wingspan: 48 feet 3 inches
Wing Area: 667 square feet
Weight: 366,138 (maximum takeoff)
Engines: Lyulka AL-31F (two). 12.5-
 ton thrust
Top Speed: Mach 2.4
Range: 2,485 miles
Crew: 1
Armament: One 30mm cannon,
 10 air-to-air missiles

RAFALE A
PROTOTYPE

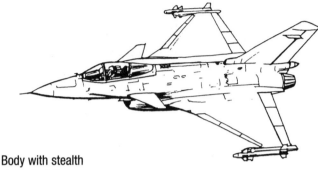

Multipurpose plane developed by France to be its principal fighter. The Rafale B and Rafale C are used by the nation's air force, while the Rafale C is used by the navy. All Rafales have moving canards (for horizontal stabilization) above the wings. Mass production of these aircraft is supposed to begin in 2005.

Body with stealth characteristics.

Apart from its use as a conventional land-and-sea attack and reconnaissance aircraft, the Rafale can also be equipped with nuclear armament.

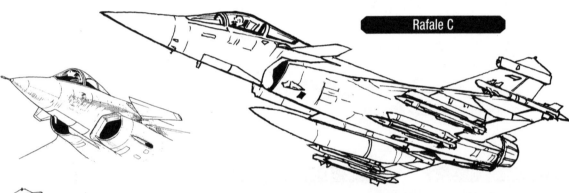

Rafale C

Height: 17 feet 6 inches
Length: 50 feet 3 inches
Wingspan: 35 feet 9 inches
Wing Area: 495 square feet
Weight: 42,990 lbs (B/C), 47,400 (M) (maximum takeoff)
Engines: Snecma M88 (two), 7.4-ton thrust
Top Speed: Mach 2
Range: 1,151 miles
Crew: 1 (C/M), 2 (B)
Armament: One 30mm cannon, six air-to-air missiles, 7,716-pound payload

Removable Electronic Rudder

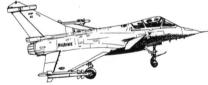

Launch bar for the M-type front-wheel catapult

Rafale M

ECM (electronic countermeasures) antenna

A new type of fighter developed jointly by Britain, Germany, Italy and Spain. Because each country has its own requirements for the aircraft, it has become multifunctional.

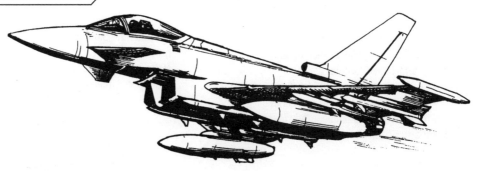

Height: 21 feet
Length: 47 feet 7 inches
Wingspan: 34 feet, 5.5 inches
Wing Area: 538 square feet
Weight: 46,297 lbs (maximum takeoff)
Engines: EJ2000 (two), 9.2-ton thrust
Top Speed: Mach 2
Range: 683 miles
Crew: 1
Armament: One 27mm cannon, six air-to-air missiles, 14,330-pound payload

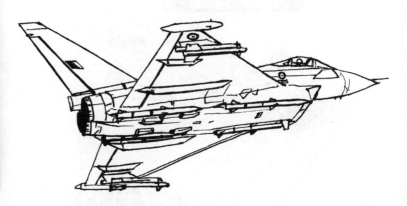

The first prototype EAP (Experimental Aircraft Program) was flown in Britain by a British Aerospace pilot.

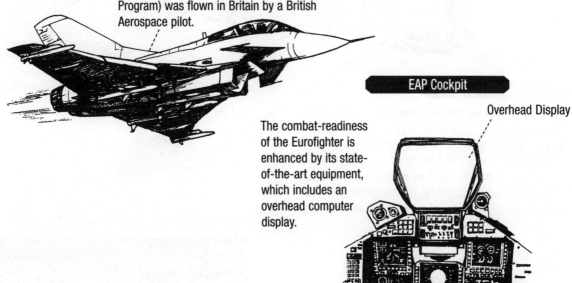

EAP Cockpit

Overhead Display

The combat-readiness of the Eurofighter is enhanced by its state-of-the-art equipment, which includes an overhead computer display.

The first prototype Zero, a carrier-based aircraft capable of regularly reaching and defeating land-based targets, was introduced during the Second Sino-Japan War. When the Chinese learned of the new plane's tremendous capabilities, they feared the worst and began their retreat.

JAPANESE NAVY (1939)
MITSUBISHI/NAKAJIMA ZERO

Taking its nickname from the final digit of the year (1940) in which the plane entered service, the Zero was Japan's principal aircraft throughout World War II. Mitsubishi and Nakajima built 10,449 of these Zeros, making it the most-produced Japanese plane of the war.

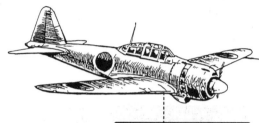

Model 11 (1940)

Model 22 (1943)

The Model 22, which had a greater flying range than the Model 32, was used during the epic Battle of Guadalcanal.

Model 21 (1941)

It was called "Invincible" at the start of the war, known to the world as Zero Fighter.

Model 32 (1942)

Early versions of the Zero were equipped with the 940-horsepower Sakae 12 engine. But the need for speed led to the introduction of the Model 32 and its 1,130-horsepower Sakae 21. The Model 32 also dispensed with the folding wingtips found on its predecessors. It wasn't the success that the Japanese had hoped for: The new plane simply didn't perform as well as previous models, and very few were ever built.

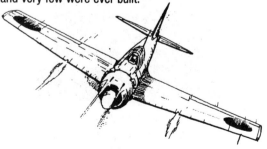

Height: 11 feet 5.75 inches
Length: 30 feet
Wingspan: 36 feet 1 inch
Wing Area: 229 square feet
Weight: 6,504 lbs (maximum takeoff)
Engine: Nakajima NK1C Sakae 21, air-cooled, 1,130 hp
Top Speed: 350 mph
Range: 1,118 miles
Crew: 1
Armament: Two 20mm cannons, two 7.7mm guns

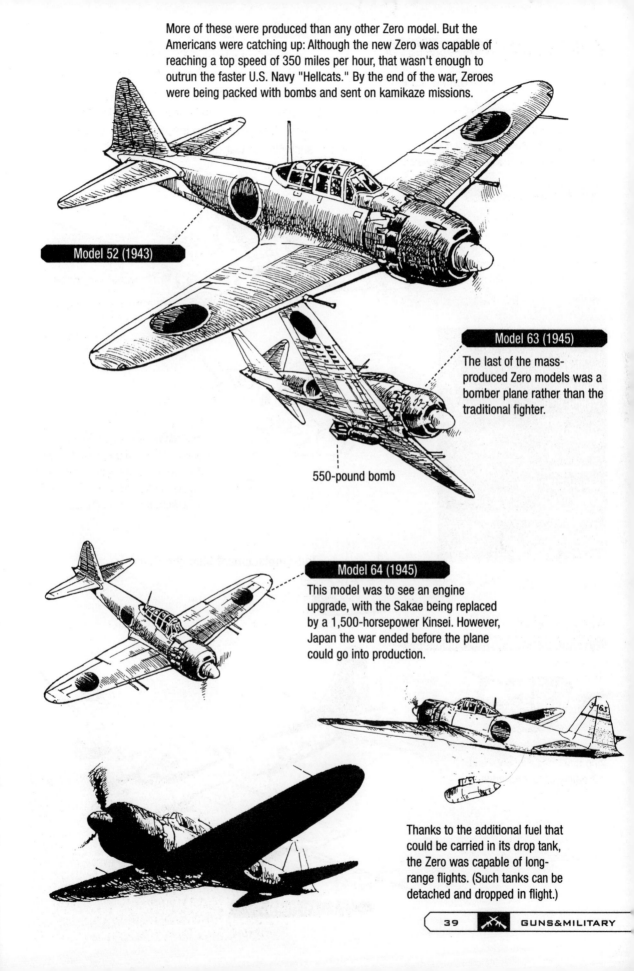

More of these were produced than any other Zero model. But the Americans were catching up: Although the new Zero was capable of reaching a top speed of 350 miles per hour, that wasn't enough to outrun the faster U.S. Navy "Hellcats." By the end of the war, Zeroes were being packed with bombs and sent on kamikaze missions.

Model 52 (1943)

Model 63 (1945)

The last of the mass-produced Zero models was a bomber plane rather than the traditional fighter.

550-pound bomb

Model 64 (1945)

This model was to see an engine upgrade, with the Sakae being replaced by a 1,500-horsepower Kinsei. However, Japan the war ended before the plane could go into production.

Thanks to the additional fuel that could be carried in its drop tank, the Zero was capable of long-range flights. (Such tanks can be detached and dropped in flight.)

Long-range bombers, which the U.S. military considered prohibitively expensive prior to World War II, became a "build 'em at any cost" necessity during the war. And the payoff was huge, as the aptly named Flying Fortresses pounded the enemy into submission. Scenes featuring these imposing aircraft can be enjoyed in such classic war movies as "Twelve O'Clock High" and "Memphis Belle."

U.S. ARMY (1935)
BOEING B-17, FLYING FORTRESS BOMBER

B-17F (1942)

The Flying Fortress was the United States' first four-engine bomber, and it played a crucial role in the war against Germany, destroying countless military facilities and traffic routes.

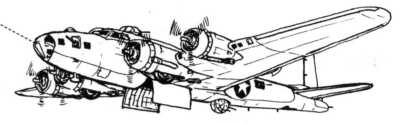

Height: 19 feet 1 inch
Length: 74 feet 9 inches
Wingspan: 103 feet 9 inches
Wing Area: 1,418.6 square feet
Weight: 60,000 lbs (maximum takeoff)
Engines: Wright R-1820-97 (four), air-cooled, 1,200 hp
Top Speed: 295 mph
Range: 1,100 miles
Crew: 10
Armament: Thirteen 12.7mm guns, 6,000-pound bomb payload

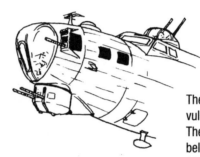

The B-17F was shown to be vulnerable to attacks from the front. The two machine guns in the turret below the bomber's nose on the B-17G were remote-controlled.

Tail-Emplacement Machine Guns

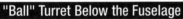

"Ball" Turret Below the Fuselage

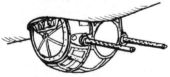

The gunner who sat here for the long flight had a lonely—and extremely dangerous—job.

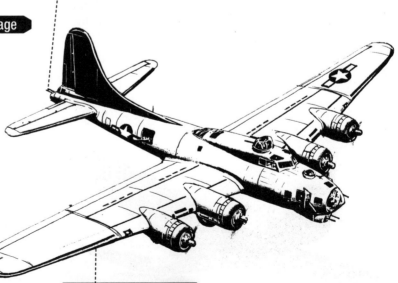

B-17 G (1943)

The United States felt the B-17 and its cousin, the B-24 Liberator, were sufficient for battle in Europe. The B-29 Superfortress was therefore reserved for use only against Japan. On June 15, 1944, a B-29 made its way to the Japanese island of Kyushu and bombed a steelworks factory, thus launching a campaign to cripple Japan's wartime industries. With no Japanese interceptor capable of counterattacking the squadrons of B-29s, the bombers conducted their raids on major cities throughout the country unimpeded. On August 5, 1945, the B-29 "Enola Gay" dropped the world's first atomic bomb on Hiroshima, and a second atomic bomb was dropped by a B-29 on Nagasaki three days later, ending the war.

Tail-Emplacement Gun
Although early versions of the B-29 were equipped with a 20mm cannon in the tail, this weapon was removed when the U.S. military realized it wasn't needed against the weaker Japanese aircraft.

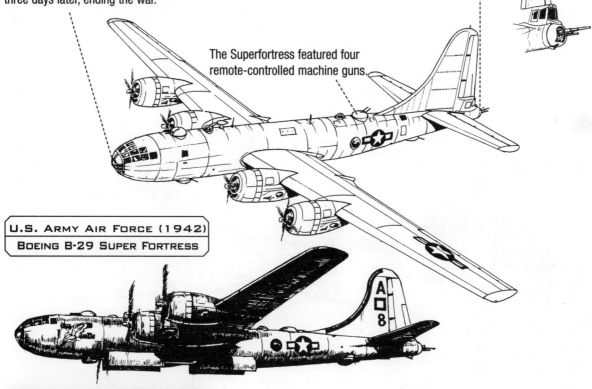

The Superfortress featured four remote-controlled machine guns.

U.S. ARMY AIR FORCE (1942)
BOEING B-29 SUPER FORTRESS

Height: 27 feet 9 inches
Length: 99 feet
Wingspan: 141 feet 3 inches
Wing Area: 1,736 square feet
Weight: 141,100 lbs (maximum takeoff)
Engines: Wright R-3350-41 (four), air-cooled, 2,200 hp
Top Speed: 358 mph
Range: 4,100 miles
Crew: 10
Armament: Twelve 12.7mm guns, one 20mm cannon, 20,000-pound bomb payload

The B-29 normally carried 20 to 30 cluster bombs, each of which was packed with 38 to 60 M69 incendiary devices. Thus, a single B-29 bomber could drop up to 1,800 M69s, and more than 100 B-29s would fly together on a single air raid!

One 5,000-pound cluster contained 38 to 60 M69s.

Types of Bombs Dropped Over Japan by B-29s

M69 Incendiary Device

The M69s spill out of the cluster at an altitude of 1,000 feet.

M34 (2,000 lbs)

M44 (1,000 lbs)

M43 (500 lbs)

M47 (100 lbs) Incendiary Bomb

Incendiary Devices

U.S. Army Air Force (1940)
North American B-25 Mitchell Bomber

Height: 15 feet 9 inches
Length: 52 feet 11 inches
Wingspan: 67 feet 7 inches
Wing Area: 610 square feet
Weight: 28,460 lbs (maximum takeoff)
Engines: Wright Double Cyclone R-2600-9 (two), 1,700 hp
Top Speed: 322 mph
Range: 1,300 miles
Crew: 5
Armament: Six 12.7mm guns, 3,000-pound bomb payload

On April 18, 1942, sixteen B-25B bombers took off from the aircraft carrier USS Hornet in the daring "Doolittle Raid," so named after the mission's commander, Lt. Col. James H. Doolittle. The successful mission marked the first U.S. attack against mainland Japan, with the aircraft bombing four cities, including Tokyo. The original B-25 model carried bombs as its main armament. Other armaments were subsequently added in front for anti-aircraft and low-altitude attacks.

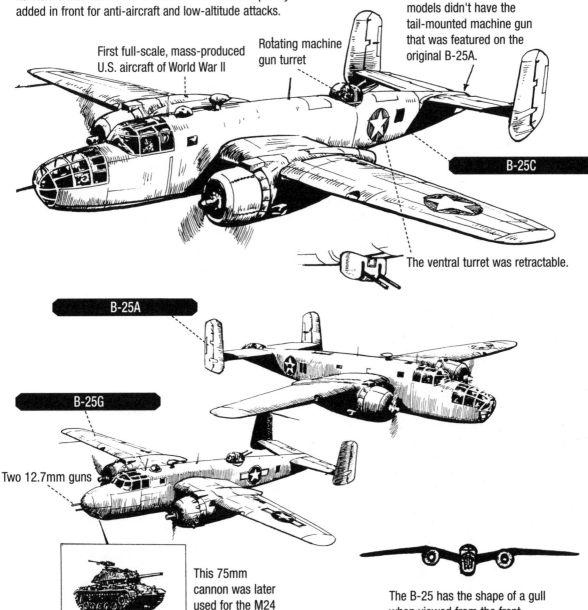

First full-scale, mass-produced U.S. aircraft of World War II

Rotating machine gun turret

The B-25B and some later models didn't have the tail-mounted machine gun that was featured on the original B-25A.

B-25C

The ventral turret was retractable.

B-25A

B-25G

Two 12.7mm guns

This 75mm cannon was later used for the M24 Chaffee light tank

The B-25 has the shape of a gull when viewed from the front.

Twelve 12.7mm guns, 3,000-pound bomb payload

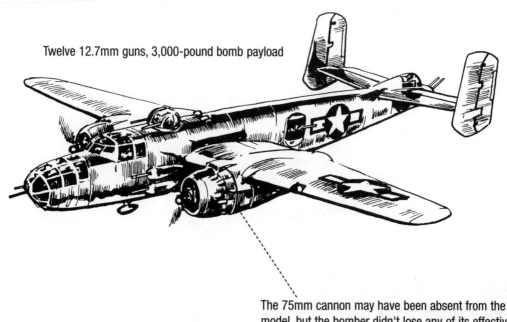

B-25J

The 75mm cannon may have been absent from the final model, but the bomber didn't lose any of its effectiveness. (A few B25Js were equipped with eight 12.7mm guns up front, rather than the standard four). Strong and easy to control, it remained popular with pilots—and with Hollywood: Many war movies have scenes featuring these workhorse aircraft.

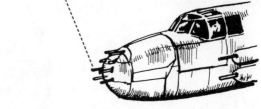

B-25H

Equipped with 14 12.7mm guns and one 75mm cannon, the B25H was the most heavily armed U.S. bomber yet. It was particularly effective at low-altitude attacks against ground positions.

A machine gun was again installed at the tail.

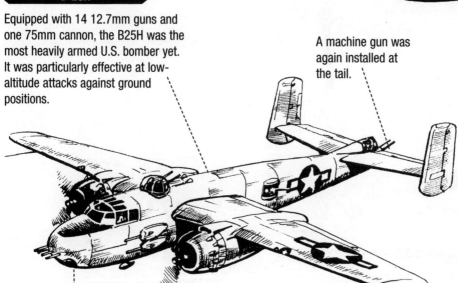

The nose-mounted 75mm cannon was rarely used.

UNITED STATES (1978)
McDONNELL DOUGLAS F/A-18 HORNET

The designation "F/A" indicates that this aircraft is capable of serving as either a fighter or attack aircraft, depending on the armament configuration. F/A-18s can be seen going up against the deadly UFOs in the special-effects blockbuster "Independence Day."

Equipped with a sidewinder AAM at the end of each wing.

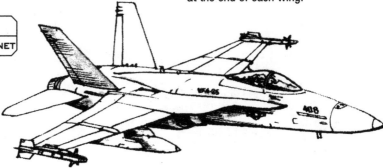

F/A-18C

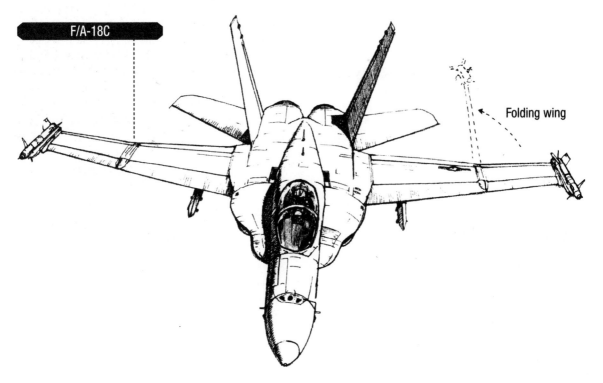

Folding wing

F/A-18A

The bottom of the aircraft has nine external weapons stations.

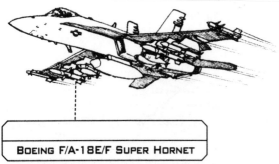

BOEING F/A-18E/F SUPER HORNET

This enhanced version has a larger body, greater range and more armament than its McDonnell Douglas cousin.

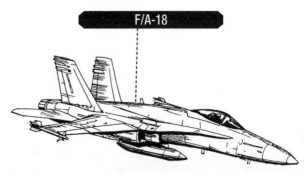

F/A-18

F/A-180

A highly effective nighttime fighter; seats two.

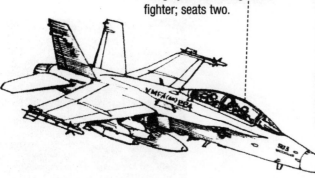

Height: 15 feet 3.5 inches
Length: 56 feet
Wingspan: 40 feet 5 inches with tip-mounted AAMs
Wing area: 400 square feet
Weight: 49,224 lbs (maximum takeoff)
Engines: General Electric F404-GE-400 (two), 7.2-ton thrust
Top Speed: Mach 1.8
Range: 460 miles (fighter), 662 miles (attack)
Crew: 1
Armament: One 20mm Vulcan cannon, six air-to-air missiles or 17,000-pound bomb payload

Bombs

Rocket launcher

7 bombs

19 bombs

Fuel tank

AGM-62 Walleye guided glide bomb

AGM-65 Maverick

Braking fin on a snake-eye bomb

GBU-10E Paveway laser-guided bomb

MK20 Rockeye cluster bomb

AIM-9M Sidewinder

AIM-7M Sparrow

AIM-120 AMRAAM

AGM-88 HARM

AGM-84 Harpoon

1,000-pound bomb

500-pound bomb

The so-called "Stealth Bomber," whose unique wing shape allows the bomber to evade radar detection, was a top-secret project.

UNITED STATES (1989)
NORTHROP GRUMMAN B-2 SPIRIT BOMBER

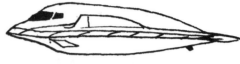

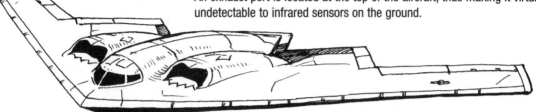

An exhaust port is located at the top of the aircraft, thus making it virtually undetectable to infrared sensors on the ground.

he surface is covered in an electromagnetic-wave absorbing material.

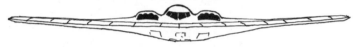

AGM-69 SRAM short-range missile

B61 nuclear bomb

The B-2s two rotary launchers have a maximum capacity of 16 nuclear bombs.

Height: 17 feet
Length: 69 feet
Wingspan: 172 feet
Weight: 376,000 lbs (maximum takeoff)
Engines: General Electric F118-GE-110 (four); 8.6-ton thrust
Top Speed: 475 mph
Range: 7,500 miles
Crew: 2
Armament: Maximum 40,000-pound bomb payload

UNITED STATES (1982)
LOCKHEED F-117A NIGHTHAWK

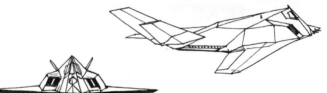

Height: 12 feet 5 inches
Length: 65 feet 11 inches
Wingspan: 43 feet 4 inches
Weight: 52,500 lbs (maximum takeoff)
Engines: General Electric F104-GE-F102 (two); 4.9-ton thrust
Top Speed: 603 mph
Range: 765 miles
Crew: 1
Armament: Maximum 5,800-pound bomb payload

The Nighthawk was the world's first stealth aircraft. Its black body, which is covered with radar wave absorbing material, is both striking and ominous.

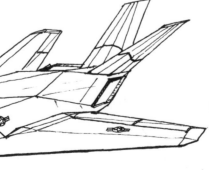

F-117A bomb bay

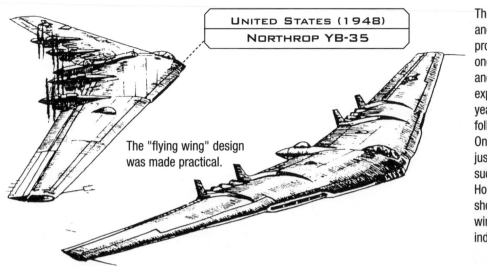

UNITED STATES (1948)
NORTHROP YB-35

The "flying wing" design was made practical.

The futuristic design and double reverse-propellers made this one of the most unusual and ambitious experiments in the years immediately following World War II. Only 13 were built, and just one of those was successfully flown. However, the project showed that a flying-wing concept could indeed be practical.

UNITED STATES (1989)
NORTHROP B-2

By the end of the 1980s, the vision behind the YB-35 had been fully realized with the introduction of the revolutionary B-2. However, due to restrictions in the U.S. defense budget, only 20 of the 132 planned aircraft were built—at a cost of about $70 billion each.

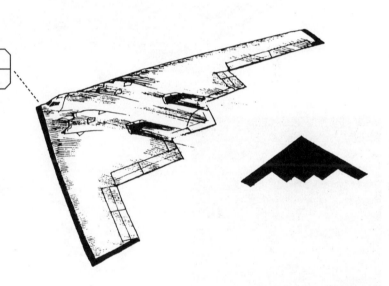

GERMANY (1945)
HORTEN HO-229A-1

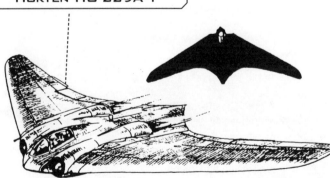

The Germans' own flying-wing aircraft was still under development at the end of the war.

UNITED STATES (1947)
NORTHROP XB-49

The YB-49, a jet-powered version of the YB-35. Two YB-49s were tested during the late 1940s.

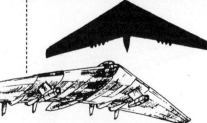

GERMANY (1935)

JUNKERS JU-87 STUKA DIVE-BOMBER

The Ju-87 Stuka is perhaps the best-known bomber of World War II. As the airborne component of the blitzkrieg, this dive-bombing plane excelled at what it was built to do. However, it was also a rather slow aircraft, and thus an easy target for Allied fighters. Unsuitable for the air war against Britain, Stuka squadrons were assigned to the Eastern Front.

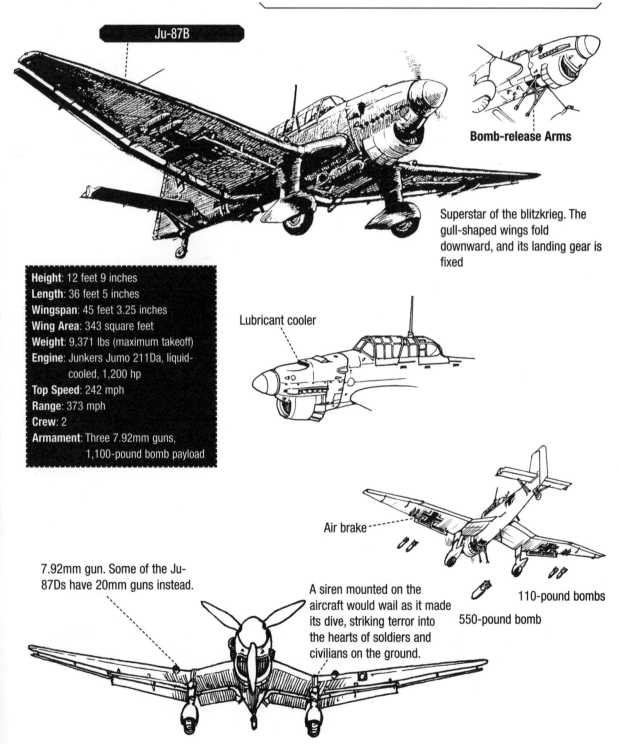

Ju-87B

Bomb-release Arms

Superstar of the blitzkrieg. The gull-shaped wings fold downward, and its landing gear is fixed

Height: 12 feet 9 inches
Length: 36 feet 5 inches
Wingspan: 45 feet 3.25 inches
Wing Area: 343 square feet
Weight: 9,371 lbs (maximum takeoff)
Engine: Junkers Jumo 211Da, liquid-cooled, 1,200 hp
Top Speed: 242 mph
Range: 373 mph
Crew: 2
Armament: Three 7.92mm guns, 1,100-pound bomb payload

Lubricant cooler

Air brake

110-pound bombs

550-pound bomb

7.92mm gun. Some of the Ju-87Ds have 20mm guns instead.

A siren mounted on the aircraft would wail as it made its dive, striking terror into the hearts of soldiers and civilians on the ground.

Ju-87D (1941)

The redesigned Ju-87D carried stronger engines and had a look completely different than that of earlier Stuka models.

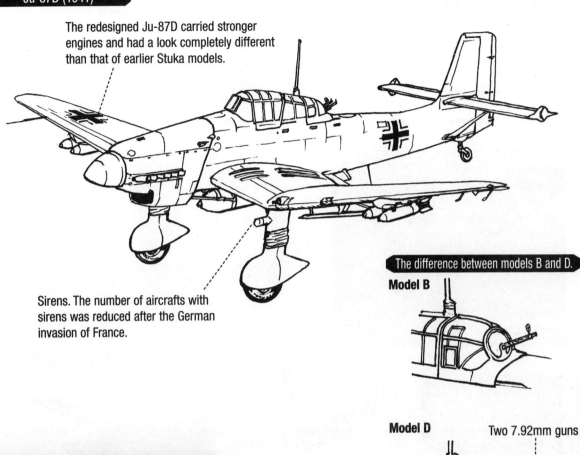

Sirens. The number of aircrafts with sirens was reduced after the German invasion of France.

The difference between models B and D.

Model B

Model D

Two 7.92mm guns

Height: 12 feet 9 inches
Length: 37 feet 9 inches
Wingspan: 49 feet 2.5 inches
Wing Area: 363 square feet
Weight: 14,500 lbs (maximum takeoff)
Engine: Junkers Jumo 211J-1, liquid-cooled, 1,400 hp
Top Speed: 250 mph
Range: 410 miles
Crew: 2
Armament: Two 7.92 mm guns, 3,500-pound bomb payload

Ju87G-1

Built as a tank-killer, the Ju-87D was equipped with 37mm cannons to target the enemy's rear engine. Only experienced pilots could manage to control it. Its distinct shape earned the aircraft the nickname "Cannon Bird."

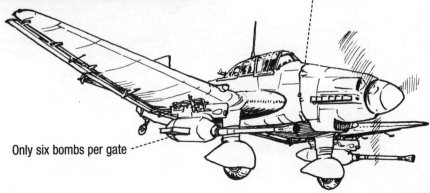

Only six bombs per gate

Avro Lancaster, Spitfire, Mosquito were three English-made masterpieces carrying the largest bomb loads and were used for attacking mainland Germany. While the US B-17 was active during the daytime, these three were effective at night missions, dropping millions of bombs like rainfall. If Spitfire could be considered the messiah of England, Lancaster was the "demon of the night" who defeated Germany.

BRITAIN (1941)
AVRO LANCASTER BOMBERS

Height: 19 feet 7 inches
Length: 69 feet 4 inches
Wingspan: 102 feet
Wing Area: Unavailable
Weight: 68,000 lbs (maximum takeoff)
Engine: Rolls-Royce or Packard Merlin 20 or 22, liquid-cooled, 1,460 hp
Top Speed: 287 mph
Range: 1,600 miles
Crew: 7
Armament: Eight 7.7mm guns, 22,000-pound bomb payload

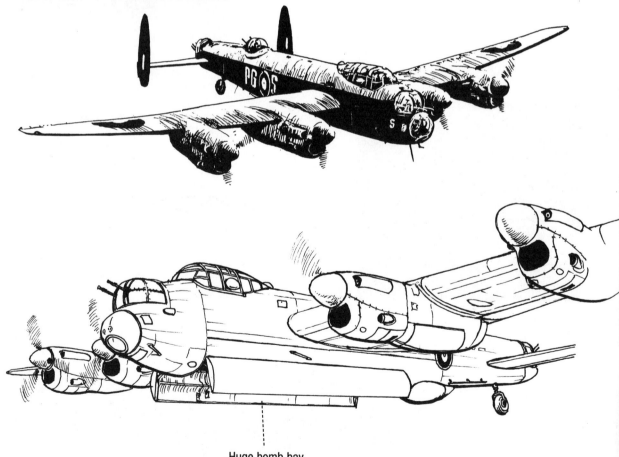

Huge bomb bay

Dam Buster

The Lancaster was the only British aircraft able to carry the 12,000-pound "Tallboy" bomb and the 22,000-pound "Grand Slam" bomb, the latter being the heaviest carried by any bomber during the war. Lancasters were responsible for the sinking of the German battleship Tirpitz and destruction of the Moehne and Eder dams in Germany.

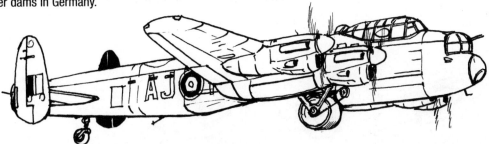

This "spinning" bomb was designed to skip across water before sinking and exploding at the base of a dam.

Four 7.7mm guns, synchronized to fire a combined 1,400 rounds a minute.

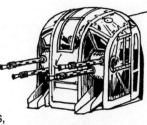

Rear Turret

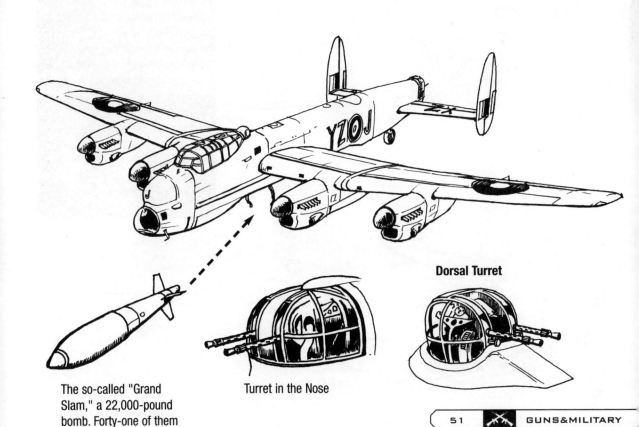

Dorsal Turret

Turret in the Nose

The so-called "Grand Slam," a 22,000-pound bomb. Forty-one of them were dropped on Germany.

At the outset of the war, two-thirds of the Italian army's bombers were Savoia Marchietti SM79s. Originally a commercial aircraft, the so-called "Sparviero" was modified for military use and played a major role in both the Spanish Civil War and World War II. With a well-deserved reputation for being a strong, high-speed bomber, the SM79 was also used for torpedo attacks and spying.

ITALY (1934)
SAVOIA MARCHETTI SM79 SPARVIERO BOMBER

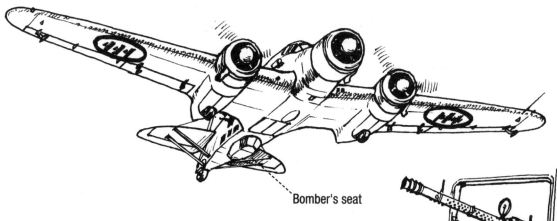

Bomber's seat

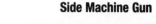

Side Machine Gun

The unique design of this aircraft featured three machine guns, with a defensive gun emplacement above and behind the cockpit humpback. The bomber's seat is located in the gondola under the center fuselage.

Height: 13 feet 5 inches
Length: 53 feet 2 inches
Wingspan: 69 feet 6.5 inches
Wing Area: Unavailable
Weight: 24,192 lbs (maximum takeoff)
Engines: Piaggio P.XIRC 40 (three), air-cooled, 1,000 hp
Top Speed: 270 mph
Range: 1,243 miles
Crew: 4
Armament: One 7.7 mm gun, three 12.7mm guns, 2,200-pound bomb payload

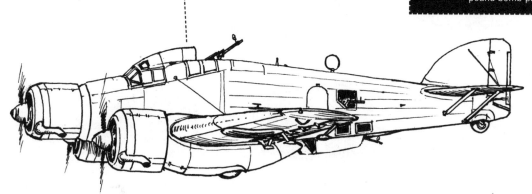

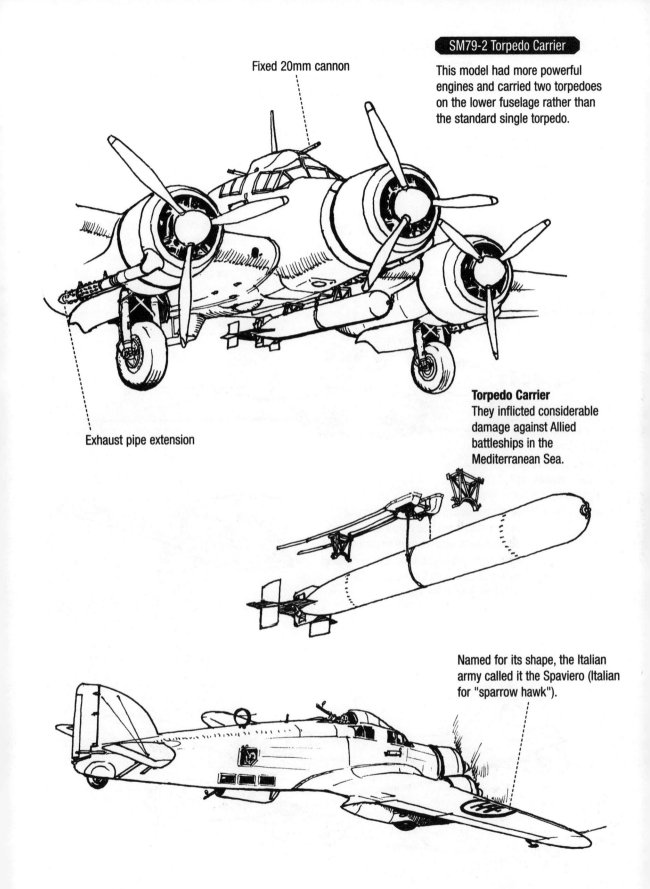

Fixed 20mm cannon

This model had more powerful engines and carried two torpedoes on the lower fuselage rather than the standard single torpedo.

Exhaust pipe extension

Torpedo Carrier
They inflicted considerable damage against Allied battleships in the Mediterranean Sea.

Named for its shape, the Italian army called it the Spaviero (Italian for "sparrow hawk").

Soviet bombers played an indispensable role in the defeat of Germany on the Eastern Front. The highest priority was placed on development of the IL-2 Sturmovik, and 36,163 had been built by war's end.

Soviet Union (1939)
Ilyushin IL-2 Sturmovik Bomber

Sturmovik means "the man who invokes the storm" in Russian. Capable of flying fast at very low altitudes, the heavily armored, single-seat Sturmovik was an extremely difficult plane for the Germans to attack. The first models were outfitted with 1,680-horsepower powerplants, 20mm cannons—and fearless pilots.

80mm-thick bulletproof glass

Lacking a sighting device, targeting was done using the front foresight and the canopy.

As losses began to mount, it became apparent that the plane was too vulnerable to attacks from behind. Therefore, subsequent models were fitted with a second seat for a gunner (and 12.7mm gun) in the rear.

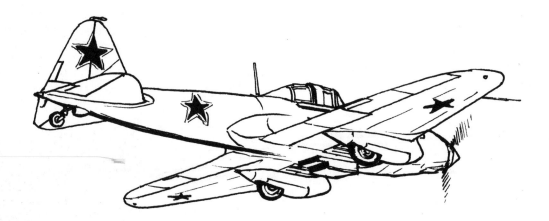

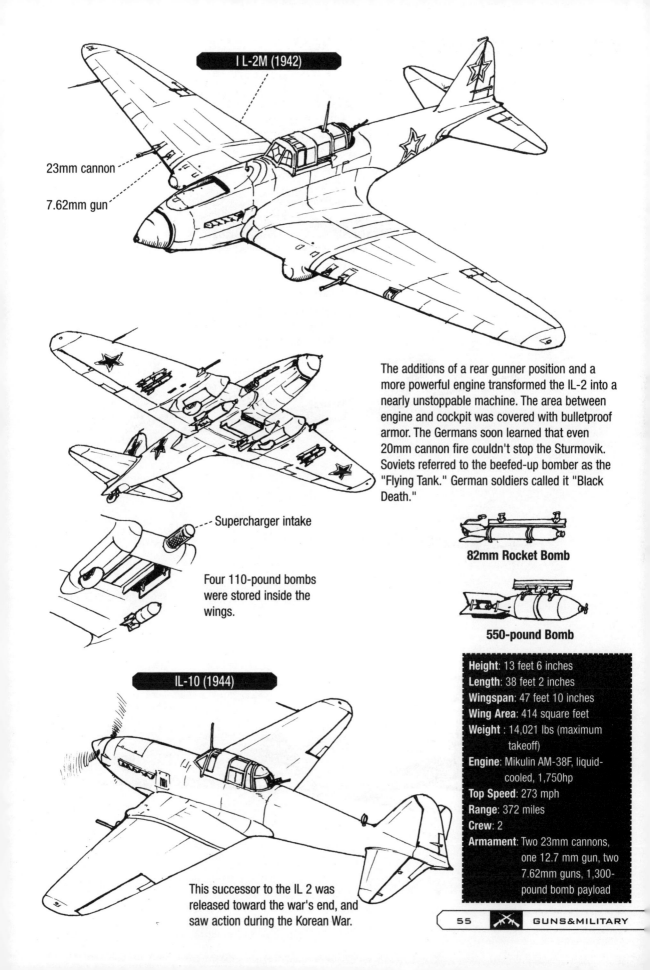

I L-2M (1942)

23mm cannon

7.62mm gun

The additions of a rear gunner position and a more powerful engine transformed the IL-2 into a nearly unstoppable machine. The area between engine and cockpit was covered with bulletproof armor. The Germans soon learned that even 20mm cannon fire couldn't stop the Sturmovik. Soviets referred to the beefed-up bomber as the "Flying Tank." German soldiers called it "Black Death."

Supercharger intake

Four 110-pound bombs were stored inside the wings.

82mm Rocket Bomb

550-pound Bomb

Height: 13 feet 6 inches
Length: 38 feet 2 inches
Wingspan: 47 feet 10 inches
Wing Area: 414 square feet
Weight : 14,021 lbs (maximum takeoff)
Engine: Mikulin AM-38F, liquid-cooled, 1,750hp
Top Speed: 273 mph
Range: 372 miles
Crew: 2
Armament: Two 23mm cannons, one 12.7 mm gun, two 7.62mm guns, 1,300-pound bomb payload

IL-10 (1944)

This successor to the IL 2 was released toward the war's end, and saw action during the Korean War.

Soviet Union (1971)

upolev Tu-22M Backfire

Height: 36 feet 3 inches
Length: 139 feet 4 inches
Wingspan: 76 feet 5.5 inches (swept) to
112 feet 5.75 inches
Wing Area: 1,500 square feet (swept) to
1,775 square feet (spread)
Weight: 273,370 (maximum takeoff)
Engines: Kuznetsov NK-144 (two), 20-ton
thrust
Top Speed: Mach 2
Range: 3,400 miles
Crew: 4
Armament: 53,000-pound bomb payload

The wings swing from 20 to 65 degrees, and it can reach a top speed of Mach 2, which is said to be a match for the U.S. B-1 bomber.

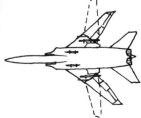

The Backfire is equipped with two supersonic engines and capable of carrying nuclear weapons. The Russian navy also uses the aircraft as a fighter for attacking battleships.

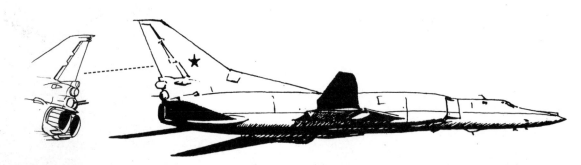

There is a remote-controlled 23mm continuous fire cannon in the tail.

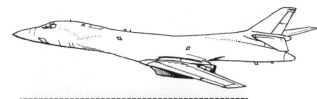

Soviet Union (1981)
Tupolev Tu-160 Black Jack

Equipped with four long-range strategic missiles, this Soviet aircraft closely resembles the U.S. B-1 bomber upon which it was obviously based.

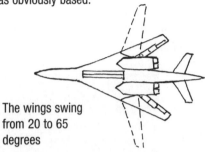

The wings swing from 20 to 65 degrees

Height: 42 feet
Length: 176 feet 10 inches
Wingspan: 110 feet 7 inches (swept) to 183 feet (spread)
Wing Area: Unavailable
Weight: 606,261 lbs (maximum takeoff)
Engines: Kuznetsov NK-321 (four); 20-ton thrust
Top Speed: Mach 2
Range: 8,699 miles
Crew: 4
Armament: 36,376-pound bomb payload

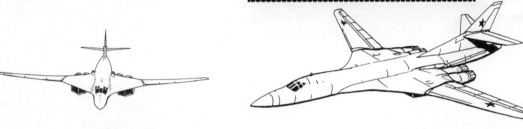

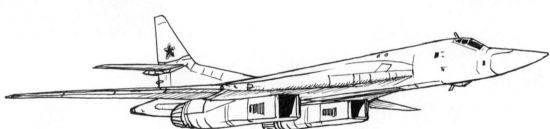

United States (1974)
Rockwell B-1B Lancer

The wings swing from 15 to 67.5 degrees

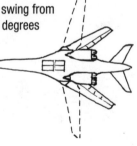

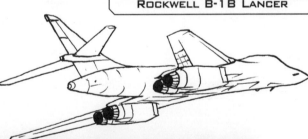

Height: 34 feet 10 inches
Length: 147 feet
Wingspan: 78 feet 2.5 inches (swept) to 136 feet 8.5 inches (spread)
Wing Area: 1,950 square feet
Weight: 477,000 (maximum takeoff)
Engines: General Electric F101-GE-102 (four), 13.6-ton thrust
Top Speed: Mach 1.25
Range: 6,449 miles
Crew: 4
Armament: 42,000-pound bomb payload combined in two internal bays

A supersonic bomber developed as a successor to the B-52, the B-1B is capable of attacking at very low altitudes.

In 1922, Japan entered the Five Power Naval Disarmament Treaty with the United States, Britain, France and Italy that limited the size and number of warships each country could maintain. This necessitated the development of large, long-range torpedo carrier-bombers to compensate for the shortage of battleships, and Japan began production of the Type 96 Attack Bomber and its subsequent model, the Type 1 Attack bomber. The latter aircraft was used from the latter half of the Second Sino-Japan War through World War II.

Its long, slender fuselage earned this aircraft the nickname "Cigar Bomber." Although possessed with exceptional range, the aircraft was deprived of the armor necessary to protect its large fuel tanks and would thus burst into flames when hit by enemy fire. As such, U.S. soldiers began referring to the model as a "one-shot lighter." Just days after the attack on Pearl Harbor, Japan dispatched G4Ms to Malaya, where the bombers destroyed two of Britain's most powerful warships, the battleship Prince of Wales and the battlecruiser Repulse.

Height 16 feet 1 inch
Length: 56 feet 6 inches
Wingspan: 81 feet 8 inches
Wing Area: 840 square feet
Weight: 28,350 lbs (maximum takeoff)
Engines: Mistubishi Kasei-11 (two), 1,530 hp
Top Speed: 265 mph
Range: 3,130 miles
Crew: 7
Armament: One 20mm cannon, four 7.7mm guns, one 1,764-pound torpedo or a 2,205-pound bomb payload

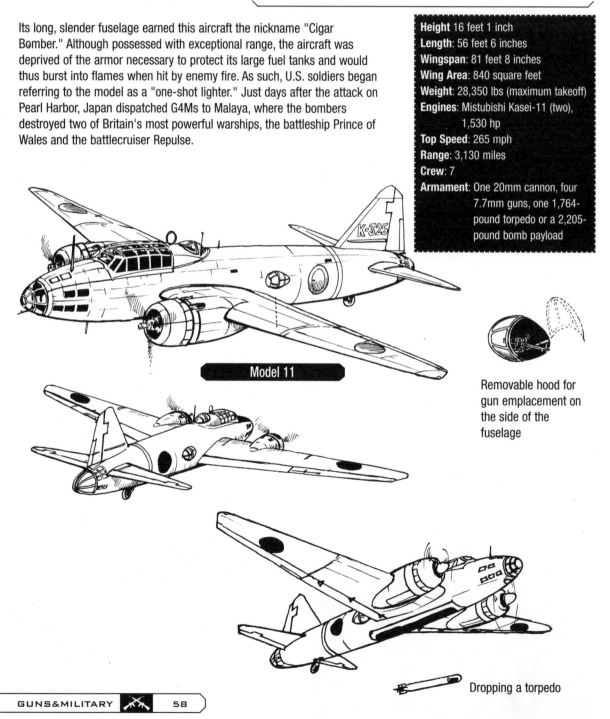

Model 11

Removable hood for gun emplacement on the side of the fuselage

Dropping a torpedo

The Model 24, equipped with two Mitsubishi Kasei-25 engines, was capable of reaching a top speed of 280 mph.

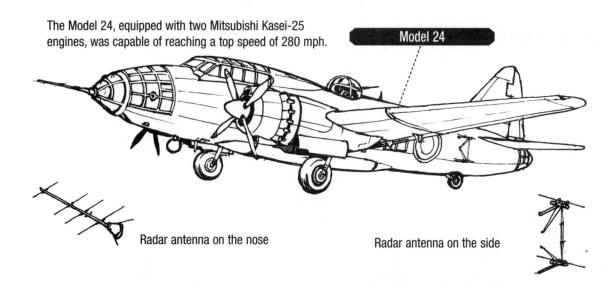

Model 24

Radar antenna on the nose

Radar antenna on the side

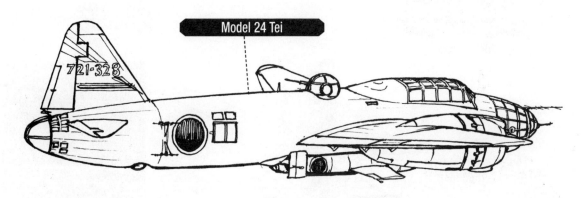

Model 24 Tei

Dorsal Machine Gun

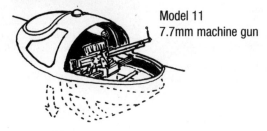

Model 11
7.7mm machine gun

Rotating hood

Model 22
Gun emplacement
on the side

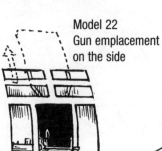

20mm powered
machine gun

20mm Machine Gun in the Tail

Model 11 to Model 22

Manually aimed
machine gun

Model 22

Model 34

The prototype AH-64 Apache first lifted off in 1975, and it has been a mainstay in the U.S. arsenal ever since. Numerous modifications and enhancements over the past three decades years have allowed this all-weather, twin-engine fighter to maintain its well-deserved reputation as the best attack helicopter in the world. The Apache can pinpoint its target even in the darkness of night, and has the enviable ability to fight both tanks and other helicopters. Hollywood superstars Tommy Lee Jones and Nicholas Cage played second fiddle to the mighty Apache in the helicopter-fueled flick "Fire Birds."

UNITED STATES (1975)
McDonnell Douglas AH-64 Apache Attack helicopter

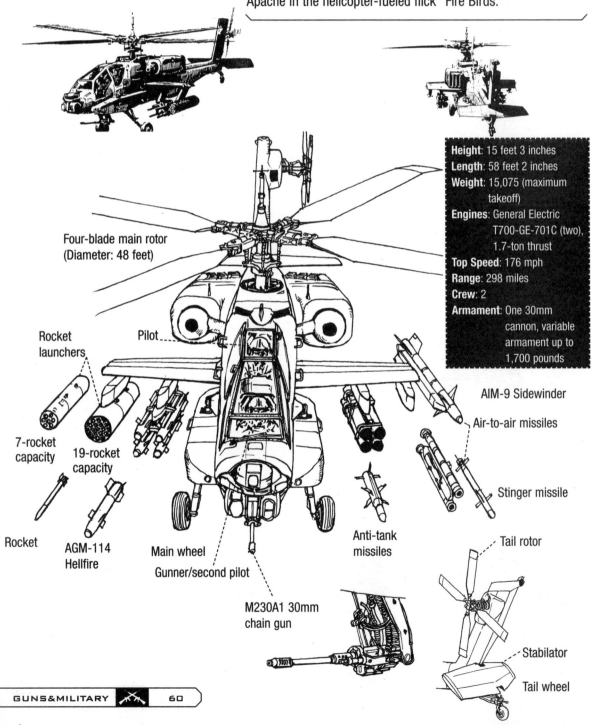

Height: 15 feet 3 inches
Length: 58 feet 2 inches
Weight: 15,075 (maximum takeoff)
Engines: General Electric T700-GE-701C (two), 1.7-ton thrust
Top Speed: 176 mph
Range: 298 miles
Crew: 2
Armament: One 30mm cannon, variable armament up to 1,700 pounds

Four-blade main rotor (Diameter: 48 feet)

Rocket launchers

Pilot

7-rocket capacity

19-rocket capacity

Rocket

AGM-114 Hellfire

Main wheel

Gunner/second pilot

M230A1 30mm chain gun

Anti-tank missiles

AIM-9 Sidewinder

Air-to-air missiles

Stinger missile

Tail rotor

Stabilator

Tail wheel

Optical Sensor Rotating Seat

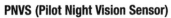

PNVS (Pilot Night Vision Sensor)

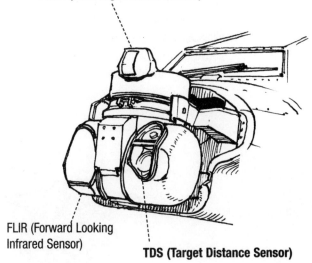

FLIR (Forward Looking
Infrared Sensor)

TDS (Target Distance Sensor)

AH-64D Apache Longbow

The latest, most advanced version
of the Apache is designed for
optimum performance regardless
of weather conditions

Longbow radar

Developed during the Cold War, the Mi-24 Hind helicopter survived the breakup of the Soviet Union and remains a symbol of Russian military might. Not just an attack aircraft, it also has a cabin in the back that can accommodate eight troops and ordnance. The Soviets exported Mi-24s to its Eastern European allies and other socialist countries to suppress guerrilla activities. The helicopters depicted in flicks such as "Rambo" and "Red Dawn" were ostensibly Mi-24s, but in reality were remodeled Sikorskys or other western helicopters modified to resemble the Hind.

SOVIET UNION (1972)
MILL MI-24 HIND ATTACK HELICOPTER

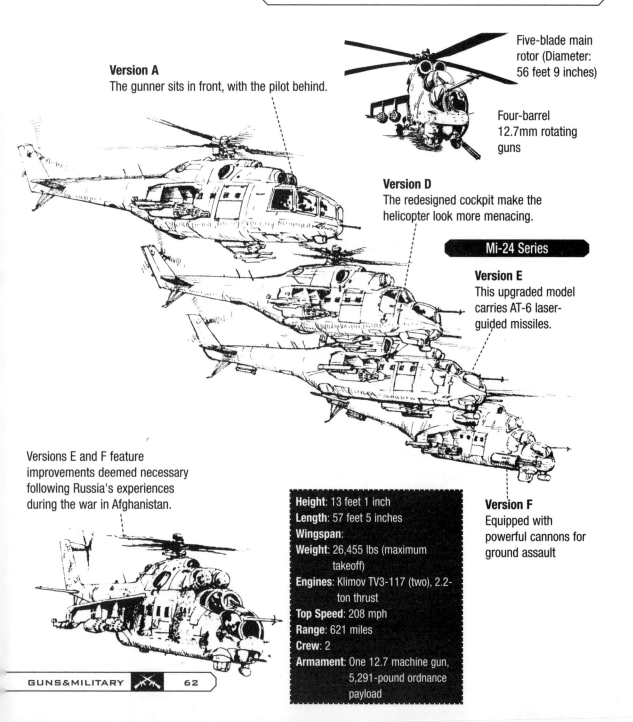

Version A
The gunner sits in front, with the pilot behind.

Five-blade main rotor (Diameter: 56 feet 9 inches)

Four-barrel 12.7mm rotating guns

Version D
The redesigned cockpit make the helicopter look more menacing.

Mi-24 Series

Version E
This upgraded model carries AT-6 laser-guided missiles.

Versions E and F feature improvements deemed necessary following Russia's experiences during the war in Afghanistan.

Version F
Equipped with powerful cannons for ground assault

Height: 13 feet 1 inch
Length: 57 feet 5 inches
Wingspan:
Weight: 26,455 lbs (maximum takeoff)
Engines: Klimov TV3-117 (two), 2.2-ton thrust
Top Speed: 208 mph
Range: 621 miles
Crew: 2
Armament: One 12.7 machine gun, 5,291-pound ordnance payload

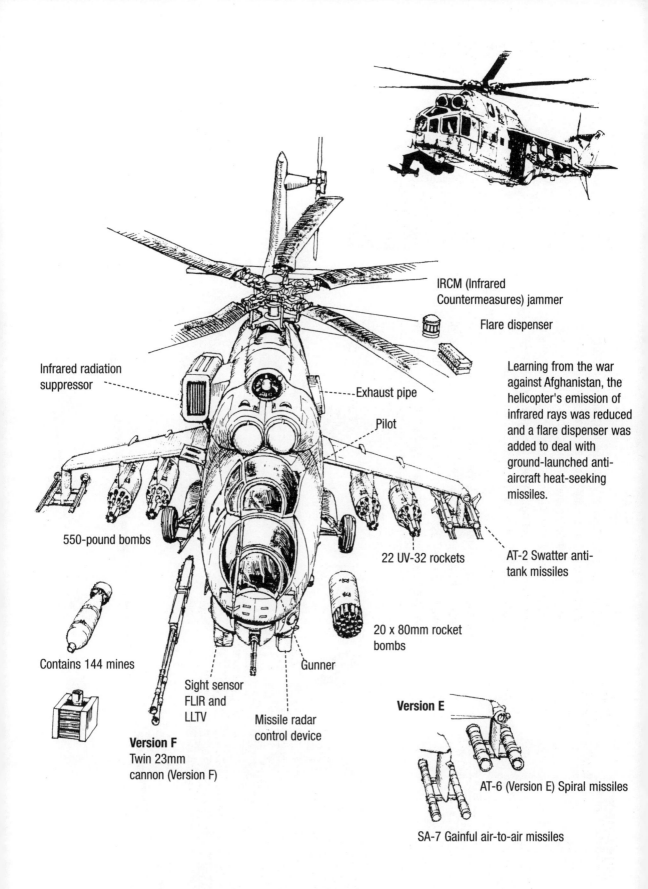

IRCM (Infrared Countermeasures) jammer

Flare dispenser

Infrared radiation suppressor

Exhaust pipe

Pilot

Learning from the war against Afghanistan, the helicopter's emission of infrared rays was reduced and a flare dispenser was added to deal with ground-launched anti-aircraft heat-seeking missiles.

550-pound bombs

22 UV-32 rockets

AT-2 Swatter anti-tank missiles

Contains 144 mines

20 x 80mm rocket bombs

Gunner

Sight sensor FLIR and LLTV

Missile radar control device

Version F
Twin 23mm cannon (Version F)

Version E

AT-6 (Version E) Spiral missiles

SA-7 Gainful air-to-air missiles

UNITED STATES (1943)
USS IOWA

The Iowa class battleships were the largest and most powerful ever built by the U.S. Navy. They were also exceptionally fast, cruising at 33 knots. To navigate through the Panama Canal, however, ships could be no more than 108 feet wide, so the Iowa class remained within that limit—but not an inch less. The six that were built, including the USS Iowa, participated in most of the U.S. counteroffensives in the Pacific Ocean. And it was aboard the USS Missouri (BB-63) on Sept. 2, 1945, that Japan formally surrendered. Though decommissioned in 1955, the Missouri was brought back into service in the 1980s, and even saw action during the 1991 Persian Gulf War. She was decommissioned for the final time in 1992.

Standard displacement: 45,000 tons
Length: 880 feet
Width: 108 feet
Draft: 38 feet (maximum navigational)
Output: 212,000 hp
Speed: 33 knots
Armament (WWII): Nine 16-inch guns in three triple turrets (two forward, one aft), 20 5-inch anti-vessel/aircraft guns in 10 twin turrets (five port, five starboard), 15 quad-mount 40mm machine guns, 60 20mm single-barrel machine guns
Armoring: Water line 12 inches,
 Deck 6 inches,
 Gun turret (front) 17 inches
Crew: 1,920
Ships in the Same Class: 6

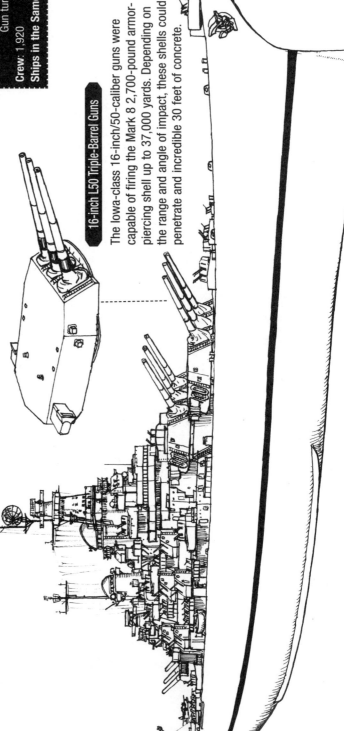

16-inch L50 Triple-Barrel Guns

The Iowa-class 16-inch/50-caliber guns were capable of firing the Mark 8 2,700-pound armor-piercing shell up to 37,000 yards. Depending on the range and angle of impact, these shells could penetrate and incredible 30 feet of concrete.

Engine cannon

The 20mm and 40mm engine guns were the two main armaments for air attacks in the Pacific War.

40mm multiple-cannon MK2

These mighty guns were particularly effective at downing kamikaze planes before they could reach their targets.

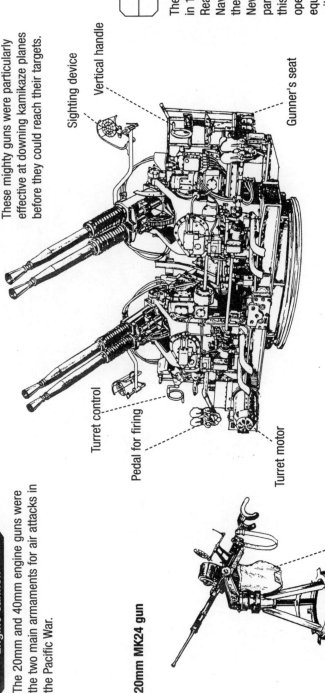

Sighting device

Vertical handle

Gunner's seat

Turret control

Pedal for firing

Turret motor

20mm MK24 gun

Cartridge receptacle

The USS New Jersey was recommissioned in 1982 as part of U.S. President Ronald Reagan's policy calling for a 600-ship Navy. Having seen action in World War II, the Korean War and the Vietnam War, the New Jersey was about to make history by participating in a fourth naval attack force, this time in support of U.S. Marines operating in Lebanon. She was well-equipped for the job, having been outfitted with eight armored box launchers for four Tomahawk cruise missiles, four quadruple canister launchers for four Harpoon missiles, and four 20mm Close-In Weapons System (CIWS) guns. There was also a takeoff/landing pad for a helicopter at the back of the main deck. The mast-like-object in front was a satellite antenna, another modern-day innovation.

Armoring:
1. Water line: 12 inches
2. Deck: 6 inches
3. Gun turret (front): 17 inches

GERMANY (1940)

BATTLESHIP BISMARCK

The Bismarck, commissioned in August 1940, was a shining example of German technological achievement. At the time of her completion, the Bismarck was said to be invincible against any battleship in the world. She boasted a top speed of 29 knots and she had a full complement of elevated guns equipped with advanced German optics to ward off air attacks. In the brief but ferocious Battle of the Denmark Strait, which lasted a mere 17 minutes on May 21, 1941, the Bismarck sank the British battle cruiser Hood and inflicted heavy damage on the British battleship Prince of Wales. The British exacted their revenge by hunting down and sinking the Bismarck in a torpedo attack a week later.

Standard displacement: 41,700 tons
Length: 813 feet 6 inches
Width: 118 feet 1 inch
Draft: 35 feet 5 inches
Output: 138,000 hp
Speed: 29 knots
Armament: Eight 15-inch guns in four twin turrets, 12 150mm guns in six twin turrets, 16 105mm elevated guns in eight twin turrets, eight 37mm elevated machine guns, 12 20mm elevated machine guns
Crew: 2,092
Ships in the Same Class: Tirpitz

Radar

Range finder

Searchlight

Navigation bridge

Compass for main gun shooting

Bridge

Elevated shooting control device

105mm elevated gun

150mm multiple auxiliary gun

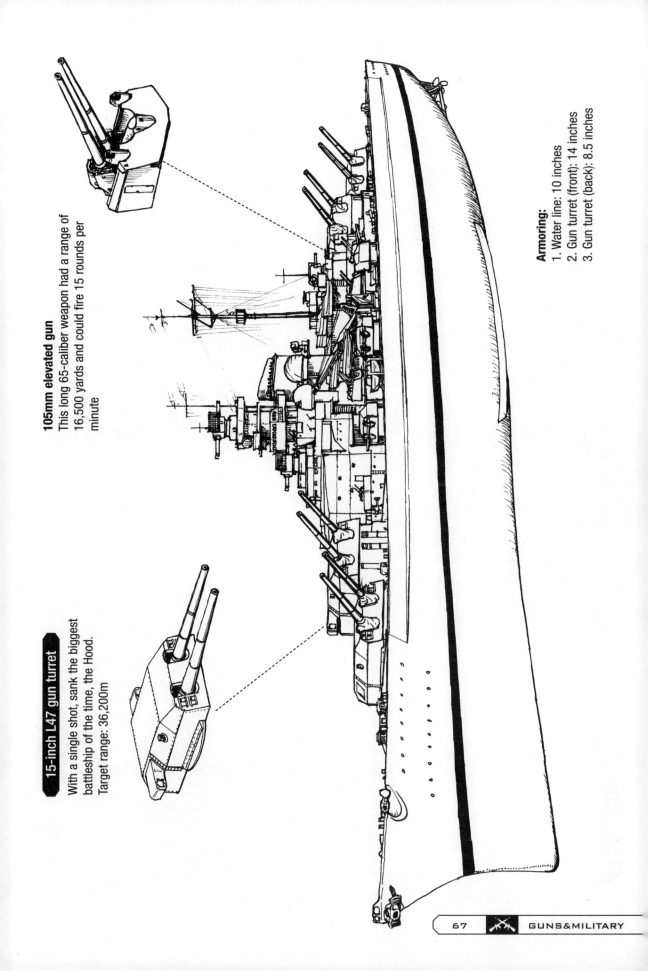

105mm elevated gun
This long 65-caliber weapon had a range of 16,500 yards and could fire 15 rounds per minute

15-inch L47 gun turret
With a single shot, sank the biggest battleship of the time, the Hood.
Target range: 36,200m

Armoring:
1. Water line: 10 inches
2. Gun turret (front): 14 inches
3. Gun turret (back): 8.5 inches

BRITAIN (1940)
BATTLESHIP, KING GEORGE V

Standard displacement: 36,727 tons
Length: 745 feet
Width: 103 feet
Draft: 29 feet
Output: 110,000 hp
Speed: 28 knots
Armament: Two 2-inch multiple gun turrets, one 14-inch multiple gun turret, eight 5-inch dual elevated guns, four 40 mm pompoms
Equipment: 2 Surface Spying Devices
Crew: 1,422
Ships in the Same Class: 5

As the disarmament treaty between Washington and London had expired, Britain constructed a new battleship called King George V. It was a state-of-the-art model and equipped with two 14-inch quadruple cannon turrets. In preparation for its upcoming battle against Bismarck, it was produced to go faster and have more firing power. It made its battle debut by engaging the Bismarck in May 1941, sinking its enemy as planned.

In the beginning, twenty multiple anti-aircraft rockets were located both at the back and the third gun turret, but neither of them were very effective. Subsequently, 40mm eight-barreled pompoms were installed. They exhibited good firepower density and firing speed, and were actively used as an anti-aircraft device. Initially, a quadruple gun was supposed to be installed in each gun turret as increased defense armament. However, to avoid increased weight, only the second turret was equipped in actual practice. Range: 22 miles. Armoring: 16 inches.

Eight-Barrel 40mm Running Gun
A powerful firing machine: 3.5-mile maximum range; each barrel firing 200 rounds per minute, yielding a total of 1,600 rounds per minute.

Armoring:
1. Water line: 15 inches
2. Gun turret: 16 inches

Initially equipped with 20-barrel rocket cannon

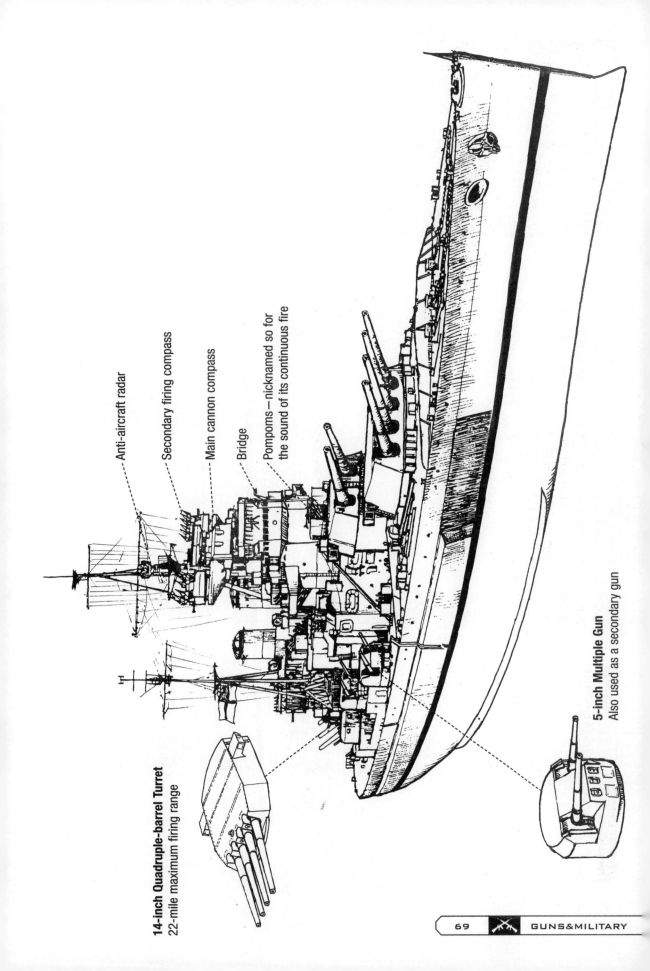

Anti-aircraft radar

Secondary firing compass

Main cannon compass

Bridge

Pompoms — nicknamed so for
the sound of its continuous fire

14-inch Quadruple-barrel Turret
22-mile maximum firing range

5-inch Multiple Gun
Also used as a secondary gun

ITALY (1940)

BATTLESHIP ROME, LITTORIO CLASS

It would have been a very good battleship if it had been able to cruise long distances. The main gun is 15 inches; since it is .50 caliber it is comparable to 16-inch guns. Rome, the third battleship of this class, was transferred to Malta, which was under British rule after Italy's surrender of the territory. Germany feared that the ship might fall into the hands of the Allies and destroyed it with the anti-marine guided missile Fritz X. The other two battleships were also dismantled.

Armoring:
Thickest armoring: 14 inches

Standard displacement: 40,724 tons
Length: 780 feet
Width: 107 feet
Draft: 31.5 feet
Output: 128,200 hp
Speed: 30 knots
Armament: Three 15-inch triple-barrel turrets, four 6-inch triple-barrel turrets, twelve 3.5-inch elevated guns, eight 1.5-inch multiple guns, eight 20mm multiple guns, four 0.8-inch guns

Crew: 1,830
Ships in the Same Class: Vittorio, Veneto, Rome

Launch tower (bridge) with a unique shape

Lifeboat on turret

6-inch secondary gun

All-round range finder

12-inch triple-barrel principal gun with 26.5-mile maximum range.

3.5-inch elevated gun

BATTLESHIP DANKERUQE

This class of mid-sized battleships were constructed during 1930s. The number of turrets was reduced by installing 13-inch quadruple-barrel guns, with an additional two turrets on the bow. The maximum speed was 29.5 knots. However, the ships weren't actively used in World War II. Fearing the German navy would use the ships itself, the French resistence sank the vessels once France was under the control of Germany.

Armoring:
Thickest armoring: 14 inches

13-inch quadruple-barrel turrets were all located in front. This long 520mm-caliber gun was said to be stronger than the main gun installed on the King George V.

Standard displacement: 26,500 tons
Width: 102 feet
Length: 704 feet
Draft: 28.5 feet
Output: 112,000 hp
Speed: 29.5 knots
Armament: Two 13-inch quadruple-barrel turrets, three 5-inch quadruple-barrel turrets, two 5-inch multiple-barrel cannons, four 1.5-inch multiple machine guns, eight half-inch quadruple guns
Crew: 1,431
Ships in the Same Class: Strasbourg

The Bridge of Strasbourg

JAPAN (1941)
BATTLESHIP YAMATO

To combat the US military power, the Japanese combined fleet produced qualitative warships, and created Yamato, the world's biggest battleship. Launched in 1937, Yamato became a strong warship equipped with nine 46cm 45caliber cannons. Considering its weight increase, a concentrated defense system was employed, covering the area between the front of the first turret and the back of the third turret. The firing speed of the main cannon was 1.8 rounds per minute with a range over 42,000m. Data has proven that it is still the best battleship ever made. In February 1942, it became a part of the combined fleet and joined battles such as the Midway operation, but failed to demonstrate sufficient ability. Its final operation was a suicide attack in Okinawa.

The Last Voyage to Okinawa (1945)

Main gun: .45-caliber 18-inch cannon with a maximum range of 26 miles. Armor-piercing power: 16 inches from a range of 19 miles. Armament: 3,200 pounds of bombs.

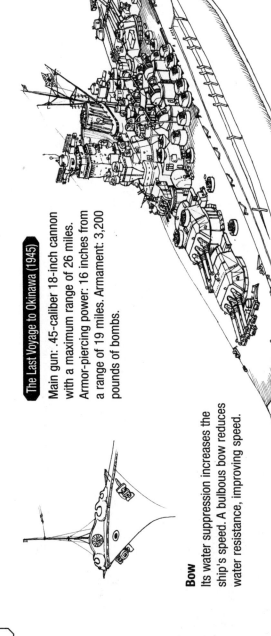

Bow
Its water suppression increases the ship's speed. A bulbous bow reduces water resistance, improving speed.

Armoring:
25 inches (in front of main turret), 9 inches (protective deck), 20 inches (conning tower)

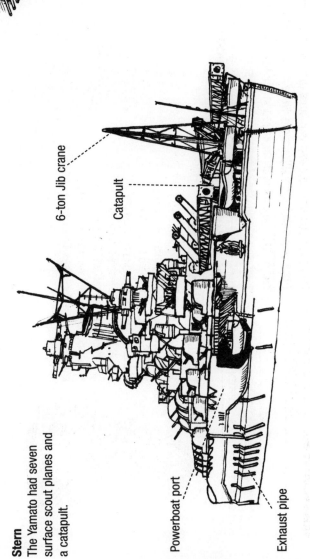

Standard displacement: 64,000 tons
Length: 830 feet
Width: 127 feet
Draft: 34 feet
Output: 150,000 hp
Speed: 27 knots
Armament: Three 18-inch turret triple-barrel turrets, four 6-inch triple-barrel guns, six 5-inch elevated guns, eight 25mm triple-barrel machine guns, two 13mm multiple machine guns

Crew: 2,500
Ships in the Same Class: Musashi

A Newly Constructed Ship

Initially, Yamato had secondary guns on both sides across the upper structure. From January to March 1944, these were removed and replaced with increased anti-aircraft armament, such as a 12.7mm multiple elevated gun and a 25mm machine gun.

Stern

The Yamato had seven surface scout planes and a catapult.

6-ton Jib crane

Catapult

Powerboat port

Exhaust pipe

UNITED STATES (1942)

AIRCRAFT CARRIER ESSEX CLASS

This U.S. aircraft battleship exhibited American production prowess. 33 of this class were produced between 1940 and 1944, and 17 of them were deployed during WWII. It became a principal aircraft carrier in the latter half of the war and was deployed in the Korean and Vietnam wars. It is worth noting that the Japanese didn't destroy a single one of these battleships.

MK37 Firing Control Device

This device was effectively used against both aircraft and vessels during WWII. Subsequently used by Japan's Maritime Self-Defense Force after the war. Able to hit battleships, fighters, and aircraft at ranges of 17 miles, 11 miles and 23 miles, respectively, it was a principal force for Essex Class air defense.

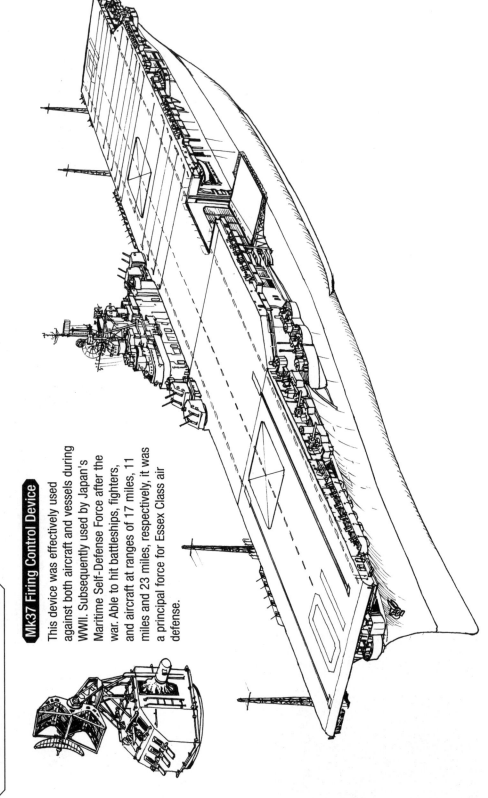

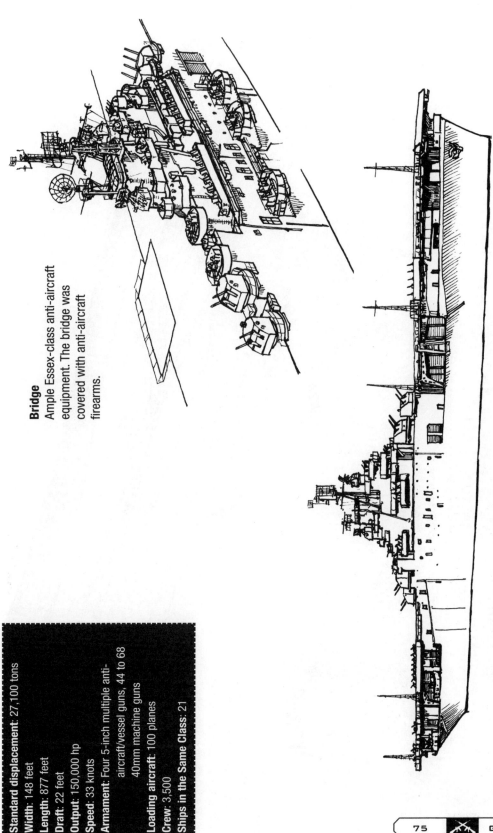

Standard displacement: 27,100 tons
Width: 148 feet
Length: 877 feet
Draft: 22 feet
Output: 150,000 hp
Speed: 33 knots
Armament: Four 5-inch multiple anti-
aircraft/vessel guns, 44 to 68
40mm machine guns
Loading aircraft: 100 planes
Crew: 3,500
Ships in the Same Class: 21

Bridge
Ample Essex-class anti-aircraft equipment. The bridge was covered with anti-aircraft firearms.

The first aircraft carrier with a lift
Chimney-bridge combination and open shades are elements showing the influence of the aircraft carrier York Town. One lift is located on the edge of the aircraft runway, whose extremely sophisticated design is comparable to the present day constructions. The aircraft runway is 866 feet long by 90 feet wide.

U.S. Postwar Super Carrier

UNITED STATES (1975)
ATOMIC POWERED AIRCRAFT CARRIER NIMITZ CLASS

U.S. postwar super carrier began with the Forrestal class and eventually developed into this Nimitz class. Complete with protective armament and atomic powered engine on the aircraft runway, it is regarded as a perfected carrier even today. A maximum of 100 aircraft can be carried. Its power is said to be equivalent to a small nation's entire air force.

Aircraft Runway
The Nimitz viewed from above. The angled deck is distinctive. The width of the aircraft runway is 250 feet.

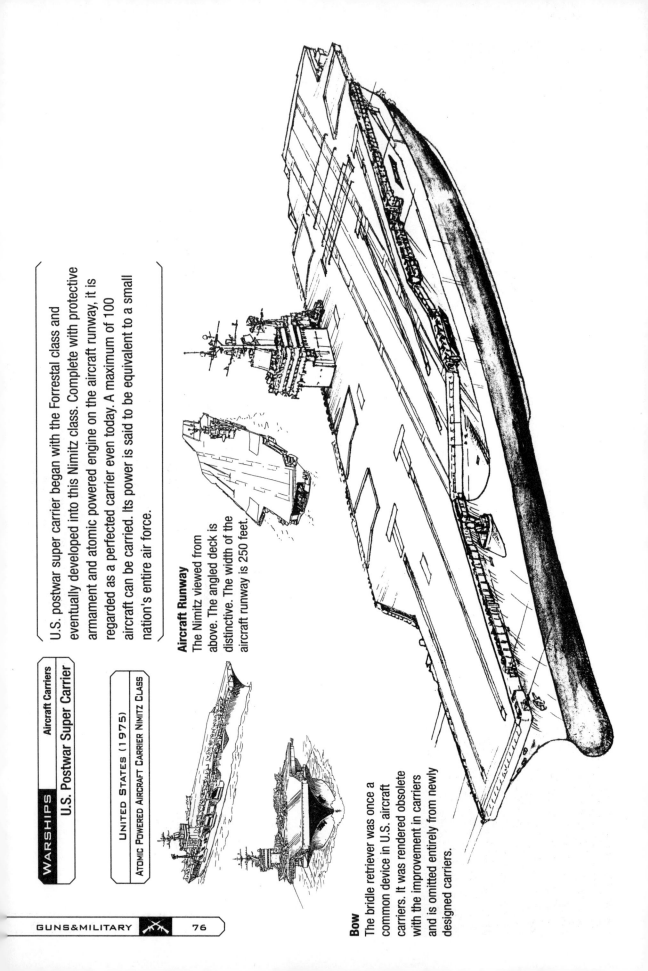

Bow
The bridle retriever was once a common device in U.S. aircraft carriers. It was rendered obsolete with the improvement in carriers and is omitted entirely from newly designed carriers.

Displacement: 91,487 tons (with full load)

Length: 1,092 feet

Width: 252 feet

Draft: 37 feet

Output: 260,000 hp

Speed: 30 knots or more

Armament: Three Sea Sparrow short-range SAM launchers, three 20mm CTW

Aircraft Capacity: 78 fixed-wing planes and helicopters (during standard operation)

Crew: 3,184, 2,800 aircraft personnel

Ships in the Same Class: 8 (Ninth and tenth ships were planned for construction at the time of this writing.)

Defensive Armament

A complete defensive armament system. Sea Sparrow has eight short-range anti-aircraft missiles. It was originally produced for aircraft fighters and subsequently modified for warships. It was used against heavy, enemy attack but the 20mm CIWS, firing at a speed of 3,000 rounds per minute, was the Nimitz's final shield. Controlling system located in the bay is fully automatic.

Anti-aircraft Sea Sparrow Missiles
9-mile firing range

CIWS (20mm Vulcan Phalanx)
1.2-mile effective range

Island (Bridge)
The bridge is alternatively called an island, as it looks to be floating on the water's surface. Main control of the ship, steering, and aircrafts is done here, with the commander of the fleet being seated in CIC, located in the ship.

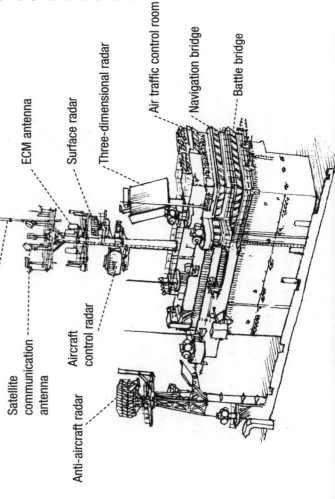

Tacan antenna

Satellite communication antenna

Anti-aircraft radar

Aircraft control radar

ECM antenna

Surface radar

Three-dimensional radar

Air traffic control room

Navigation bridge

Battle bridge

UNITED STATES (1989)
ASSAULT SHIP WASP

After the experience of heavy land battle during the Pacific War, the U.S. Navy constructed the Iwo Jima class for helicopters deployed in onshore operations. But helicopters couldn't be loaded with heavy armaments and another aircraft carrier was constructed subsequently. This was the dock-landing fleet of the Tarawa class. The Wasp class is the expanded and improved version of the Tarawa class. It was not simply a landing ship but was also used as a control center for all kinds of complicated land operations. Its appearance resembles that of an aircraft carrier but it carried a huge load of supplies and because of its "well deck" it also had a freeboard higher than that of aircraft carriers.

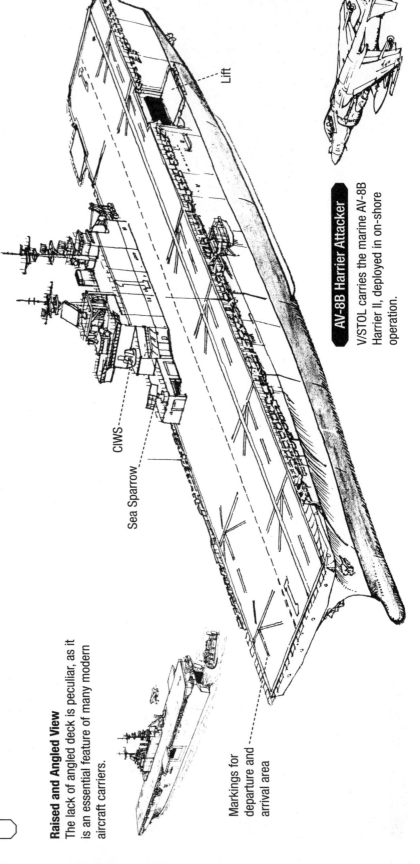

Lift

AV-8B Harrier Attacker
V/STOL carries the marine AV-8B Harrier II, deployed in on-shore operation.

CIWS

Sea Sparrow

Raised and Angled View
The lack of angled deck is peculiar, as it is an essential feature of many modern aircraft carriers.

Markings for departure and arrival area

Displacement: 40,532 tons (with full load)
Length: 844 feet
Width: 140 feet
Draft: 26.5 feet
Output: 70,000 hp
Speed: 22 knots
Armament: Two Sea Sparrow short-range SAM, two RAM short-range defense SAM, two or three 20mm CIWS, and others
Loading aircraft: Six to eight V/STOL, forty-two helicopters
Crew: 1,077, landing personnel 1,870
Ships in the Same Class: 6 (one more was under construction at the time of this writing)

Ship Interior

The stern has a vertically opening hatch with a double-leafed hinged door, dividing the area in two: a deck for aircrafts and a well deck for air-cushioned landing ships. To acclimatize the soldiers of the landing troop, there is also a compartment inside the ship that simulates the climate of the destination.

The ramp allows vehicles to move about the flying deck

Vehicle storage

Well deck

Aircraft runway

Aircraft storage

Sea sparrow

CIWS

Hinged door that enables LCAC to fit inside smoothly

LCAC-1 Air-Cushioned Landing Ship

For its speed and amphibious qualities, Japan's Self-Defense Force also uses the LCAC-1. It has a maximum load capacity of 70 tons so can carry a M1 tank.

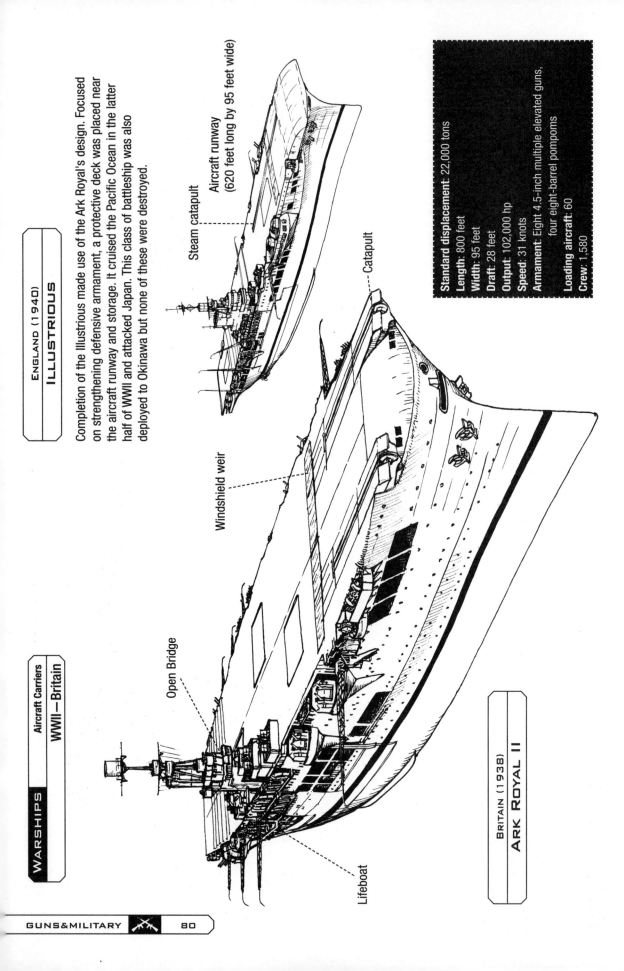

ENGLAND (1940)
ILLUSTRIOUS

Completion of the Illustrious made use of the Ark Royal's design. Focused on strengthening defensive armament, a protective deck was placed near the aircraft runway and storage. It cruised the Pacific Ocean in the latter half of WWII and attacked Japan. This class of battleship was also deployed to Okinawa but none of these were destroyed.

Aircraft runway
(620 feet long by 95 feet wide)

Steam catapult

Catapult

Windshield weir

Open Bridge

Lifeboat

BRITAIN (1938)
ARK ROYAL II

Standard displacement: 22,000 tons
Length: 800 feet
Width: 95 feet
Draft: 28 feet
Output: 102,000 hp
Speed: 31 knots
Armament: Eight 4.5-inch multiple elevated guns, four eight-barrel pompoms

Loading aircraft: 60
Crew: 1,580

Swordfish Torpedo Fighter

At the beginning of WWII, the British produced a torpedo fighter with a compound wing covered in cloth. With a performance exceeding initial expectations,, this fighter was often deployed in the war, beginning with the attack on the Bismarck.

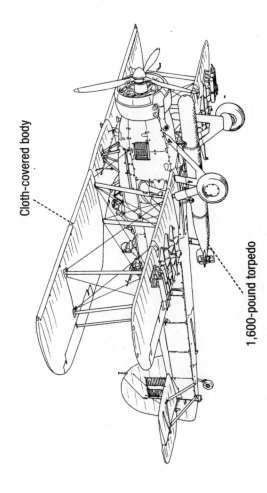

Cloth-covered body

1,600-pound torpedo

Aircraft Runway (721 feet long by 95 feet wide)
Construction of this vessel began when the world started to head towards disarmament. To achieve the widest area under displacement restrictions, the front was squared and the back was stretched out.

This vessel contributed greatly to sinking the Bismarck. Six months later, however, it was sunk by a U-boat's torpedo attack. Ark Royal had several unique features. The aircraft runway on the ground floor was also a strong protective deck connecting to the bow. There was a two-layered storage inside the hull. It should be noted that the vessel was equipped with two catapults.

BRITAIN (1982)
INVINCIBLE CLASS, ARK ROYAL

Ark Royal, the third aircraft carrier in the Invincible class, is a traditional name in the Royal Navy and shares the same name with previous types of aircraft carriers. The anti-aircraft missile, Sea Dart, was expected to shoot down missiles in flight but during the Falklands War it failed to counter Argentine fighters in nearby mountains.

Suffering from economic decline, Britain sought to increase air battle capability when at sea within a limited budget and constructed this V/STOL—a lightweight aircraft carrier in the Invincible class. Many were concerned about costs and quality but V/STOL successfully proved its ability in the Falklands War (1982). Its major detraction is that a powerful precautionary aircraft couldn't be loaded, as the vessel could not handle fixed-wing aircraft.

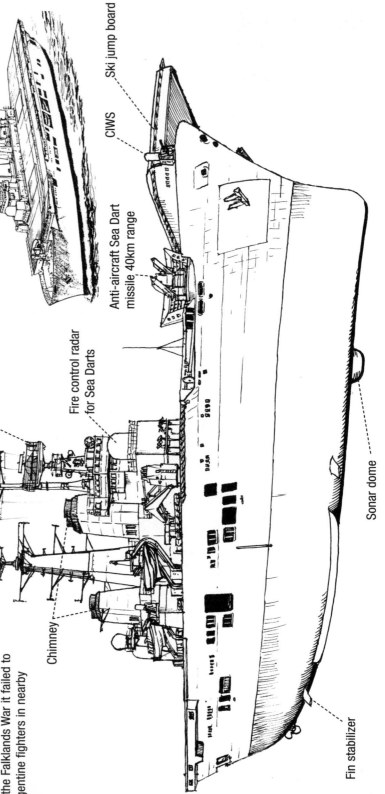

Ski jump board

CIWS

Long-range anti-aircraft radar

Fire control radar for Sea Darts

Anti-aircraft Sea Dart missile 40km range

Chimney

Sonar dome

Fin stabilizer

Displacement: 19,500 tons (with full load)
Width: 90 feet
Length: 678 feet
Output: 94,000 hp
Speed: 28 knots
Armament: One Sea Dart anti-aircraft missile, two 20mm CWS
Number of loading aircraft: 20 (V/STOL & helicopter)
Crew: 954

BAc Sea Harrier FRSI V/STOL (Fighter/Scout Plane)

During the Falklands War, it was able to demonstrate its offensive power against the Argentine air force. It was definitely better than the Forger, a fighter made in the Soviet Union.

Ski Jump Format

A Sea Harrier is taking off from the Invincible. A ski jump was used instead of a catapult. The jump angle is 7 degrees in the first two ships of this class. After the experiences in Falklands War it was reset to 12 degrees in the third ship, the Ark Royal.

France—The Latest Atomic-Powered Aircraft Carrier

FRANCE (1999)

ATOMIC-POWERED AIRCRAFT CARRIER CHARLES DE GAULLE

As a continental nation, France obtained two mid-sized aircraft carriers as a part of foreign initiatives. These two were found to be relatively old, so the French Navy constructed a new atomic-powered aircraft carrier, the Charles de Gaulle, with the latest stealth technology. It was as big as Clemenceau class and had a large aircraft runway for landing and takeoff of large aircraft. An outwardly inclined bridge, reducing detection by radar, demonstrates its stealth design.

Ark Royal, the third aircraft carrier in the Invincible class, is a traditional name in the Royal Navy and shares the same name with previous types of aircraft carriers. The anti-aircraft missile, Sea Dart, was expected to shoot down missiles in flight but during the Falklands War it failed to counter Argentine fighters in nearby mountains.

Aster

Sadral launching system

Anti-aircraft/surface radar

Carrier Landing Guidance Device

Aster

Fin stabilizer

Chaff Launcher

Anti-aircraft Missile Aster 15

Mach 2.5 at maximum speed, Aster 15 has got the ability to deal with more than one missile at a time.

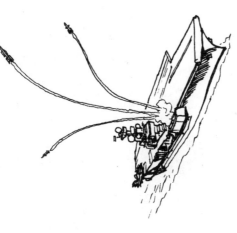

Displacement: 34,000 tons
Length: 858 feet
Width: 104 feet
Aircraft runway: 203 feet
Draft: 28 feet
Output: 76,000 hp
Speed: 27 knots
Armament: Four 8-multiple Aster 15 anti-aircraft missiles (SAM), two 6-multiple Sadral close-range, anti-aircraft missiles
Number of loading aircraft: 40 (Rafale M and others)
Crew: 1,150

Lafale M Fighter

It was planned to be carried on the Charles de Gaulle. 940km-diameter maximum flight range. Mach 2 top speed

SAM guidance radar

Anti-aircraft radar

Tacan

Infrared ray detector

Three-dimensional radar

Crane

The former Soviet Union had no experience in full-scale construction and operation of an aircraft carrier. It was impossible for them to obtain an aircraft carrier that required complicated construction and operation techniques. They had to start with the V/STOL-installed missile cruiser to learn the basics and build up to the full-scale construction of an aircraft carrier.

SOVIET UNION (1967)
MOSCOW CLASS

Kamov Ka-25 Hormone Anti-submarine Helicopter

This helicopter carrier was deployed in 1967. Leningrad is its sister ship. They both carry 14 helicopters including the anti-submarine helicopter Hormone Ka-25. It is a cruiser used to counterattack the U.S. submarine Polaris.

Displacement: 14,500 tons
Length: 620 feet
Width: 112 feet
Sea gauge: 25 feet
Output: 100,000 hp
Speed: 31 knots
Armament: Two SA-N-3 anti-aircraft launchers, one SUW-N-1 anti-vessel missile launcher, one RBU-6000 anti-submarine rocket launcher, two 57mm multiple-barrel guns
Number of loading aircraft: 14 helicopters
Crew: Approx. 850
Ships in the Same Class: Leningrad

SOVIET UNION (1987)
ADMIRAL GORSHKOV

Kamov Ka-27 Helix Anti-submarine Helicopter

Modified vessel based on the Kiev class design. The change in shape of the upper structure is apparent. In particular, the large tube-shaped radar dome is very characteristic.

Displacement: 40,000 tons
Length: 895 feet
Width: 107 feet
Draft: 33.5 feet
Output: 180,000 hp
Speed: 30.7 knots
Armament: Mostly the same as those of the Kiev
Number of aircraft: 39 (V/STOL & helicopter)
Ships in the Same Class: None

Sukhoi Su-27 Flanker fighter

Yakovlev Yak-38 Forger V/STOL

ADMIRAL KUZNETSOV

Aircraft control device

Satellite navigation device

Phased array Radar

SS-N-19 launcher

SS -N-19 6-multiple launcher

A full-scale aircraft carrier for fixed-wing aircraft. A ski jump was used since they failed in creating a steam catapult. The vessel was equipped with a Su-27-type loader.

Standard displacement: 58,500 tons
Length: 999 feet
Width: 125 feet
Draft: 34.5 feet
Output: 200,000 hp
Speed: 32 knots
Armament: Twelve VLS vertical launcher for SS-N-19 anti-vessel missiles
Twenty-four VLS for SA-N-9 anti-aircraft missiles
Number of loading aircraft: 18 (fixed wing), 17 (helicopter)
Crew: 2,100
Ships in the Same Class: Varyag (Dismantled when still under construction)

SOVIET UNION (1976)
KIEV CLASS

SA-N-3

SS-N-12

76mm multiple-barrel gun

SUW-N-1

Anti-vessel rocket launcher

A heavily armed carrier, it is a small aircraft carrier equipped with a Forger V/STOL and said to be equivalent to the Invincible class of Britain. Its helicopter was switched from Hormone to Helix (the latest model).

Displacement: 30,000 tons
Length: 720 feet
Width: 155 feet
Draft: 33 feet
Output: 200,000 hp
Speed: 32 knots
Armament: Four SS-N-12 anti-vessel missile multiple firing tubes, four SA-X-4 anti-aircraft missile launchers, one SUW-N-1 anti-submarine missile launcher, two RBU-6000 anti-submarine rocket launcher, and more.
Number of loading aircraft: 30 (V/STOL & helicopter)
Crew: Approx. 1,200
Ships in the Same Class: Kiev, Minx, Novolossiysk

JAPAN (1941)

SHOKAKU CARRIER

This Japanese aircraft carrier was constructed after the disarmament treaty was signed. Japan became free from all restriction and created this aircraft carrier to the best of its ability at the time. It was said to be a modified model of Hiryu and had stronger defensive power and extended range. It was always in the center of battles such as Pearl Harbor, the Indian Ocean, and the Coral Reef Ocean, but was defeated and sunk in the battle of the Mariana Islands. Its sister ship, Zuikaku, was destroyed off the Philippine archipelago.

Signal mast

94-format high launcher

Binoculars for guard men

Aeronautic defense control room

Search light control/compass for anti-aircraft guard

Bell

Landing and takeoff control room

Speaker

Compass bridge

Anti-aircraft Defensive Armament

28-barreled 12cm Anti-aircraft Rocket
2.8-mile maximum firing range. It made a debut in 1944 in the battle in the Philippine archipelago.

89-Format .40-caliber 5-inch Elevated Gun
9-mile maximum firing range

96-Format 25mm Triple-barrel Gun
0.8-mile effective firing range. Fires 230 rounds per minute.

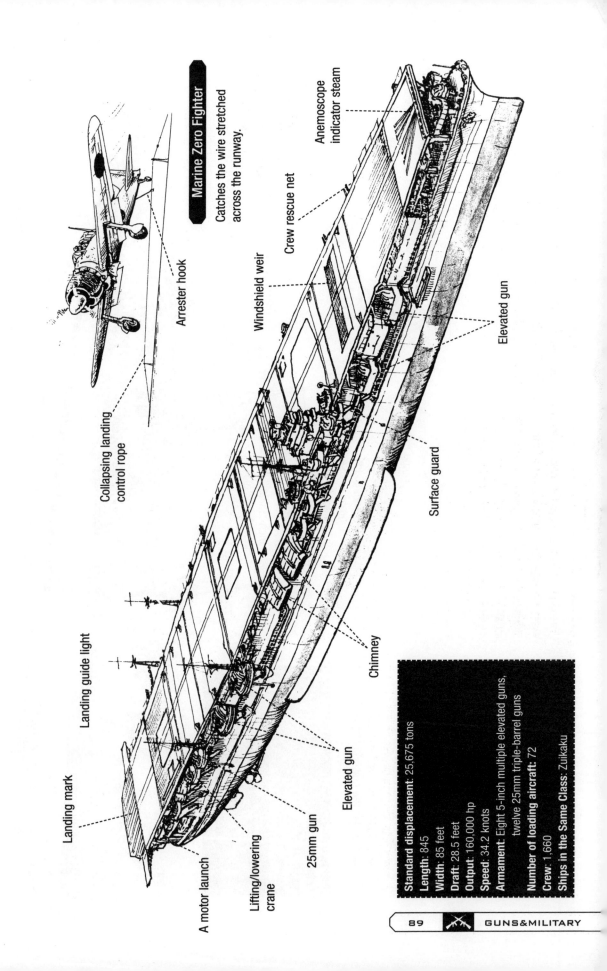

Marine Zero Fighter

Catches the wire stretched across the runway.

Arrester hook

Collapsing landing control rope

Windshield weir

Crew rescue net

Anemoscope indicator steam

Elevated gun

Landing guide light

Landing mark

A motor launch

Lifting/lowering crane

25mm gun

Elevated gun

Surface guard

Chimney

Standard displacement: 25,675 tons
Length: 845
Width: 85 feet
Draft: 28.5 feet
Output: 160,000 hp
Speed: 34.2 knots
Armament: Eight 5-inch multiple elevated guns, twelve 25mm triple-barrel guns
Number of loading aircraft: 72
Crew: 1,660
Ships in the Same Class: Zuikaku

UNITED STATES (1961)
LONG BEACH

The world's first atomic-powered cruiser, constructed as a security guard for another cruiser, the Enterprise. The bridge is surrounded with phased array radar, making its appearance was stylish as ever, but due to renovations was dismantled in the first half of the 1980s.

Displacement: 17,100 tons (with full load)
Length: 722 feet
Speed: 30 knots or more
Armament: One Talos SAM launcher, two Terrier SAM launchers, one 127mm single-barrel gun, one ASROC anti-submarine missile, two torpedo firing tubes

The United States once planned to create an atomic-powered cruiser fleet. Enterprise (aircraft carrier), Long Beach, and Bain Bridge were considered for atomic power but the plan was abandoned due to cost.

RIM-2A Terrier
Long-range 3T missile. 11.5-mile firing range. There was also the mid-range missile RIM-24 Tartar.

RIM-8 Talos
The world's first practically usable anti-aircraft missile for vessels. It is the super-long distance version of the 3T missile. It has a 74.5-mile firing range.

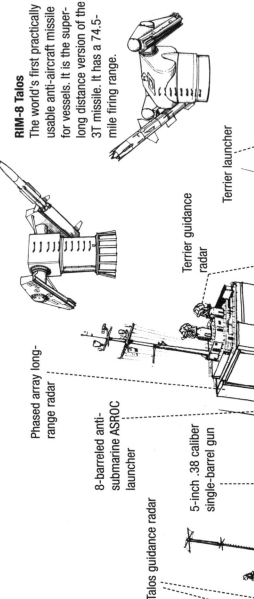

Phased array long-range radar

8-barreled anti-submarine ASROC launcher

Terrier guidance radar

Terrier launcher

Triple-barrel anti-submarine torpedo launcher

Talos guidance radar

5-inch .38 caliber single-barrel gun

Talos launcher

Heliport

The world's first atomic-powered aircraft carrier. The lack of a chimney was a strong signifier of the vessel's new atomic power. The aircraft runway was 257 feet long.

Standard displacement: 75,700 tons
Length: 1,123 feet
Width: 252 feet
Draft: 39 feet
Output: 280,000 hp
Speed: 33 knots
Armament: Three Sea Sparrow short-range SAM launchers, three CIWS

Loaded aircraft: 78
Crew: 3,215

UNITED STATES (1962)
BAIN BRIDGE

It was the atomic-powered version of the Reich class. It was still frigate in the beginning but was later promoted to become the United States's third atomic-powered cruiser.

Displacement: 8,580 tons (with full load)
Length: 565 feet
Width: 58 feet
Speed: 30 knots or more
Armament: Two Terrier SAM launchers, one 76mm gun, one ASROC anti-submarine missile, two torpedo missile launch bays

GERMANY (1936)
ADMIRAL GRAF SPEE

Signing the Versailles Treaty after its defeat in WWI, Germany arms were tightly restricted. Warship displacement was limited to 10,000 tons or less and armaments were limited to 11-inch or smaller guns. Deutschland was, therefore, the strongest and largest that the Germans could construct within regulation. It was faster than other ships with bigger guns. It also had more offensive capacity than other cruisers, for which it was formally called the "Armored Ship" at the time of completion. Admiral Graf Spee was the third ship in this class. Germany regarded it as a commerce destroyer and called it a pocket warship. It concentrated on destroying commerce in South Atlantic Ocean. In December 1939 it was damaged in the battle of the River Plate, where it was subsequently scuttled (despite its attempt to flee to the port).

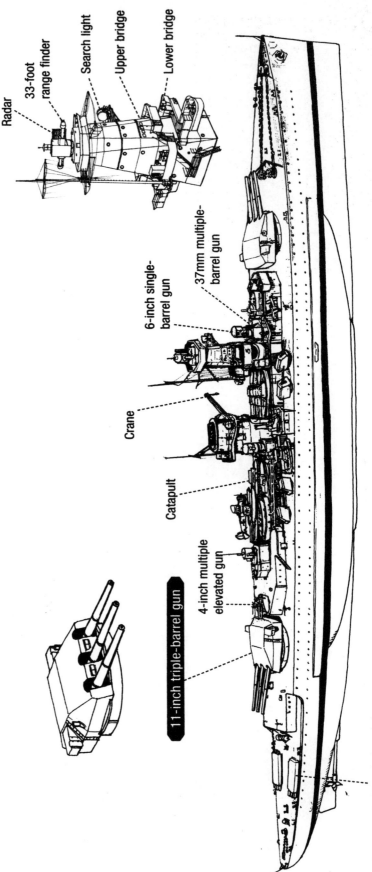

Radar

33-foot range finder

Search light

Upper bridge

Lower bridge

6-inch single-barrel gun

37mm multiple-barrel gun

Crane

Catapult

4-inch multiple elevated gun

11-inch triple-barrel gun

21-inch quadruple torpedo launch bay

Standard displacement: 11,700 tons

Length: 610 feet

Width: 71 feet

Draft: 19 feet

Output: 54,000 hp

Speed: 28 knots

Armament: Two 11-inch triple-barrel gun turrets, eight 6-inch guns, two 4-inch multiple elevated guns, four 37mm multiple guns, and various other armaments

Crew: 1,150

Ships in the Same Class: 3

Arado Ar 196

A typical German scout plane carried by cruisers or bigger warships. Gehring, an air force commander, did not allow the navy to obtain the aircraft, so those that were carried by warships all belonged to the German air force.

JAPAN (1965)
AMATSUKAZE

Launched in 1963, it was the first missile escort warship in the history of Japan Maritime Self-Defense Force. There was a Tartar anti-aircraft missile launcher (single-barrel) at the back, which was later updated to a standard SM-1 missile. It is now obsolete.

Standard displacement: 3,050 tons
Length: 430 feet
Width: 44 feet
Draft: 14 feet
Output: 60,000 hp
Speed: 33 knots
Armament: Standard SM-ISAM, ASROC anti-submarine missile, Hedge Hog anti-submarine depth charges, two torpedo launch bays, and other carrier-based cannons

Crew: 280
Ships in the Same Class: None

Tartar launcher

3-inch multiple gun

JAPAN (1968)
TACHIKAZE

The second generation of missile escort warships in Japan Maritime Self-Defense Force. Tachikaze was one level larger than Amatsukaze. It also had single-barrel missile launcher at the back but was initially equipped with a standard launcher. With later improvements, the launcher was replaced with anti-vessel missile harpoon capability.

Standard displacement: 3,850 tons
Length: 469
Width: 47 feet
Draft: 15 feet
Output: 60,000 hp
Speed: 32 knots
Armament: Standard SM-ISAM, ASROC anti-submarine missile, two torpedo launch bays, two 20mm CIWS, and other armaments.

Crew: 240
Ships in the Same Class: Asakaze, Sawakaze

5-inch gun

Standard SM-1 missile launcher

JAPAN (1986)
HATAKAZE

A successor to Tachikaze. Following JMSDF's plan, it has a gas turbine engine. Missiles were installed in front while anti-vessel missile was installed at the back near the chimney.

Standard displacement: 3,850 tons
Length: 469
Width: 47
Sea gauge: 15
Output: 60,000 hp
Speed: 32 knots
Armament: Standard SM-ISAM, ASROC anti-submarine missile, two torpedo launch bays, two 20mm CIWS, and other armaments.

Crew: 240
Ships in the Same Class: Asakaze, Sawakaze

Standard launcher

ASROC

Harpoon

CIWS

5cm gun

JAPAN (1988)
KONGO

Fourth generation in Japanese escort warships. Capable of dealing with multiple targets at the same time, it was equipped with US AEGIS System. A phased array radar was located on the side of the upper structure, which has secured Kongo's tall form. With excellent control, this could surely be the flagship of Japanese cruisers.

Anti-vessel Missile Harpoon
Very popular anti-vessel missile among Western navies. 110km maximum firing range. It has the stealth feature of being able to fly just above the water's surface. It sank small, Iraqi ships in the Gulf War.

Anti-submarine Torpedo Rocket, ASROC.
The torpedo is attached to the top of a rocket and is thus shuttled to its target.

RIM 24 Tartar
17.7km firing range. Standard missiles have replaced 3T missiles currently.

RIM-66 Standard

Anti-aircraft Missile
Missile development for Japan's escort warships has a similar history in the US. Though Terrier and Talos were developed before Tartar, these missiles were not planned to be installed in Japanese escort warships.

CIWS

CIWS

5in. gun

Vertical launch system equipped on the Kongo

Standard displacement: 7,250 tons
Length: 528 feet
Width: 69 feet
Draft: 20 feet
Output: 100,000 hp
Speed: 30 knots
Armament: Standard SAM, Harpoon anti-vessel missile, ASROC anti-submarine missile, two 20mm CWS, two torpedo launch bays, and other armaments.
Crew: 300
Ships in the Same Class: Kirishima, Myoko, Chokai

VLS (vertical launcher system)
Capable of firing many missiles all at once without reloading. The Kongo had 29 pads on front deck and 61 on the back deck.

Soviet Union Cruiser

SOVIET UNION (1980)
KIROV-CLASS FRUNZE

The first nuclear cruiser made by the Russian navy. It was the biggest of all warships when introduced, excepting aircraft carriers. Also known as a missile platform on the sea, it could damage the U.S. fleet with its long-range anti-vessel missiles. There are four of this type, but the first two have been retired from service. The fourth and fifth are still in use.

While US Navy was able to show their maximum air force power on the aircraft carrier, the former Soviet Union could not gain enough back up from air forces as they did not have an aircraft carrier. Therefore, post-war warships of the former Soviet Union had anti-aircraft, anti-vessel, and anti-submarine armament. Becoming a heavily armed warship was the only way it could compete with the US. Both Frunze and Slava were good examples of this.

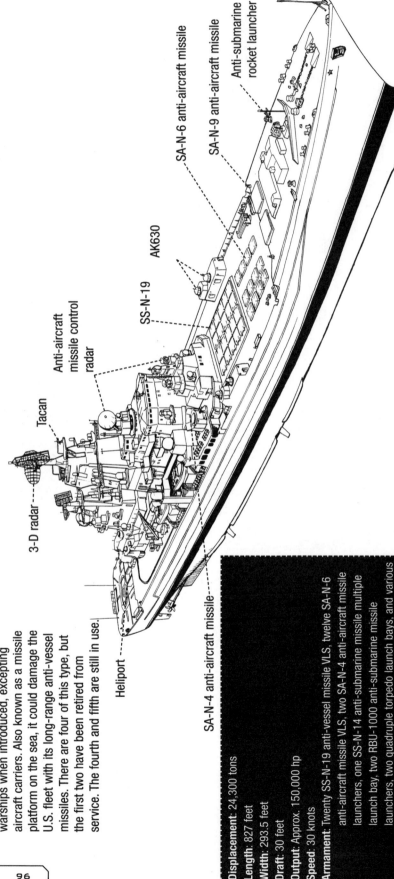

3-D radar

Tacan

Anti-aircraft missile control radar

SS-N-19

AK630

SA-N-6 anti-aircraft missile

SA-N-9 anti-aircraft missile

Anti-submarine rocket launcher

Heliport

SA-N-4 anti-aircraft missile

Displacement: 24,300 tons
Length: 827 feet
Width: 293.5 feet
Draft: 30 feet
Output: Approx. 150,000 hp
Speed: 30 knots
Armament: Twenty SS-N-19 anti-vessel missile VLS, twelve SA-N-6 anti-aircraft missile VLS, two SA-N-4 anti-aircraft missile launchers, one SS-N-14 anti-submarine missile multiple launch bay, two RBU-1000 anti-submarine missile launchers, two quadruple torpedo launch bays, and various other carrier-based armaments
Crew: Approx. 800

AK 130, 130mm .70-caliber Multiple Automatic Gun

Both Kielov and Slava classes were equipped with a 130mm .70-caliber gun. A powerful gun, firing at a speed of 30 to 45 shots per minute. 18-mile firing range.

AK 630 30mm CIWS

A typical defense fire system for warships made in the Soviet Union. There were six Gatling guns firing at 3,000 rounds per minute. It's peculiar that they haven't been put together with the radar dome, as has been done on the U.S. Navy's Phalanx.

Anti-vessel Missile

Propelled with turbo jet power, both can carry nuclear arms and target land and cruise missiles. Compared with those of the West, anti-vessel missiles made in former Soviet Union/Russia were relatively longer in range.

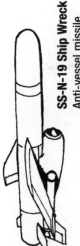

SS-N-19 Ship Wreck
Anti-vessel missile.
620km firing range

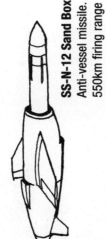

SS-N-12 Sand Box
Anti-vessel missile.
550km firing range

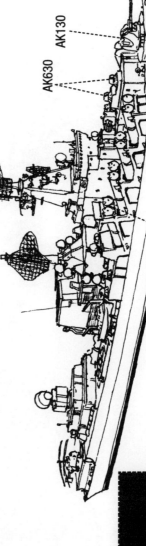

SS-N-12 launch bay.

MISSILE CRUISER SLAVA

Named "Little Kilov," indicating the vessel's its relative status. There were total of 8 anti-vessel missile launch bays on both sides of the bridge. Like Kilov, it was constructed as an attacker in surface battles.

Displacement: 11,200 tons
Length: 610 feet
Width: 68 feet
Draft: 25 feet
Output: 110,000 hp
Speed: 32 knots
Armament: Eight SS-N-12 anti-vessel missile multiple launchers, eight SA-N-6 anti-aircraft missile VLS, and other armaments
Crew: 700

United States Destroyer

UNITED STATES (1942)
FLETCHER CLASS

From mid-WWII onward, Fletcher kept its status as a principal U.S. destroyer. A total of 175 were produced. The bow turret was later improved to a flat, protective deck type. The design flexibility made it easy to increase in anti-aircraft armament. Nineteen were sunk during WWII.

Standard displacement: 2,050 tons
Length: 377 feet
Width: 39 feet
Draft: 18 feet
Output: 60,000 hp
Speed: 37 knots
Armament: Five 5-inch single anti-aircraft/vessel guns, two to five 40mm multiple guns, two 21-inch torpedo launch bays
Crew: 300

MK4 firing guidance device

Bofors 40mm multiple-barrel gun

21-inch 5-multiple torpedo launch bay

Torpedo missile system

Torpedo missile system

5-inch .38-caliber MK 30

Sub-automatic dual gun. Firing speed of 15 to 22 rounds per minute. 10-mile firing range

5-inch .54-caliber MK 45 Gun

Maximum angle of incidence: 65 degrees

Firing speed of 16 to 20 rounds per minute

14-mile maximum firing range

Standard displacement: 8,422 tons
Length: 505 feet
Width: 67 feet
Draft: 20.5 feet
Output: 105,000 hp
Speed: 32 knots
Armament: VLS for Tomahawk/Standard/ASROC, Harpoon anti-vessel missile, torpedo missile, and other armaments.

Crew: 303

Firing control system with internal search/range-finding radar

6 Gatling guns

Drum missile storage

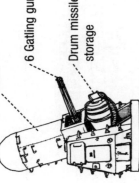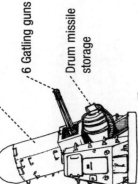

20mm CIWS Phalanx MK 15/16

UNITED STATES (1991)
ARLEIGH BURKE CLASS

It was equipped with a simplified version of the AEGES system that installed on the Ticonderoga destroyer. Its appearance is peculiar due to the phased array radar. Yet its bridge does not look as big as that of the Ticonderoga. In this sense, it has a rather small image. There are three types, distinguished by helicopter landing and electronic device capability.

Destroyers

Japan

JAPAN (1939)
KAGERO-CLASS DESTROYER YUKIKAZE

Kagero destroyers were required to be better than those of the Asashio class in terms of armament and speed. The length of Kagero would have to be over 394 feet to meet such a demand. Speed was limited to 35 knots to extend cruising range. It went to all the battles in Pacific Ocean and all but the Yukikaze were attacked and sunk. Yukikaze was a very strong destroyer, surviving many wars. After the war, it was given to China as compensation and was subsequently used by the Taiwanese navy with the name Tanyo.

The symbol of the Japanese navy, the chrysanthemum crest, is missing on warships that are the size of destroyers or smaller. These smaller ships were often ridiculed by the crew members of larger ships.

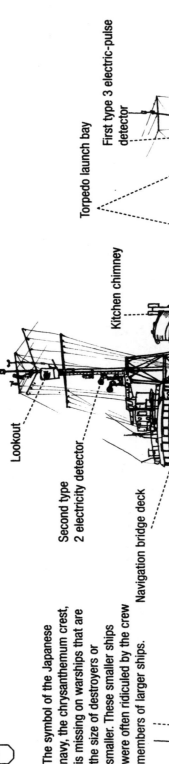

Ship Condition when Deployed with the Yamato in 1945

First type 3 electric-pulse detector

Torpedo launch bay

Kitchen chimney

Lookout

Second type 2 electricity detector

Navigation bridge deck

Standard displacement: 2,000 tons

Length: 388 feet

Width: 35.5 feet

Draft: 12.5 feet

Output: 52,000 hp

Speed: 35 knots

Armament: Three 5-inch multiple guns, two 25mm multiple-barrel guns, two torpedo launch bays

Crew: 239

Ships in the Same Class: 19

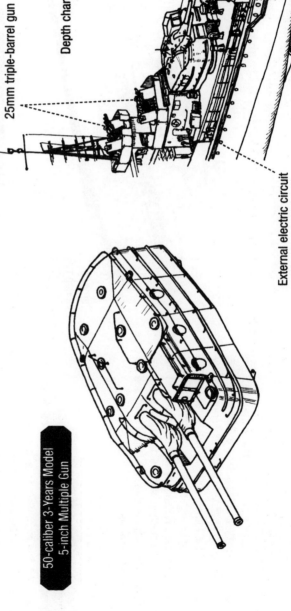

Torpedo dropping track

25mm single-barrel gun

Depth charge launcher

25mm triple-barrel gun

External electric circuit

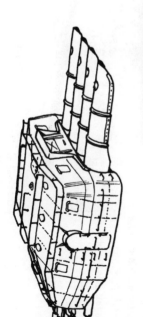

Type 92 Quadruple Torpedo Launch bay

50-caliber 3-Years Model 5-inch Multiple Gun

UNITED STATES (1941)
PT BOAT TORPEDO CARRIER ELCO 80 FEET

Standard displacement: 54 tons
Length: 80 feet
Width: 20.5 feet
Draft: 5 feet
Output: 4,050 hp
Speed: 39 knots
Armament: 21-inch torpedo, two 5-inch guns
Crew: 17

Bomb

Some Elco have four torpedo launch bays.

Torpedo launch bay

PT boat is another name for torpedo carrier, which is mainly used to defend the seashore. 802 boats were produced during WWII, 228 of which were rented by England and the former Soviet Union. It was feared that this ship, using its high speed, would go on a warship-killing rampage. J.F. Kennedy was a captain aboard the PT 109, which crashed with the Japanese destroyer Amagiri—wherein the ship was ripped apart and the crew was left adrift at sea.

UNITED STATES (1977)
HYDROFOIL MISSILE PATROL COMBATANT PEGASUS

Displacement: 239.6 tons (with full load)
Length: 133 feet
Speed: 48 knots
Armament: Two Harpoon anti-vessel missile quadruple launch bays, one 76mm single-barrel gun

Harpoon SSM quadruple firing system

Hydrofoil is raised during slow cruising.

Canard Type

The first ship was completed in 1977. It was too costly to produce another. Yet, five more were to be produced between 1981 and 1983 thanks to pressure from Congress. Initially a cooperative development with NATO, the project became the sole responsibility of the US due to exorbitant expenditure.

OT Melara 76mm .62-caliber Super Rabbit Gun
7.5-mile firing range
120 rounds per minute

SS-N-2 STYX

First used in the second Middle East War in 1967. Became the first missile to hit and sink a warship.

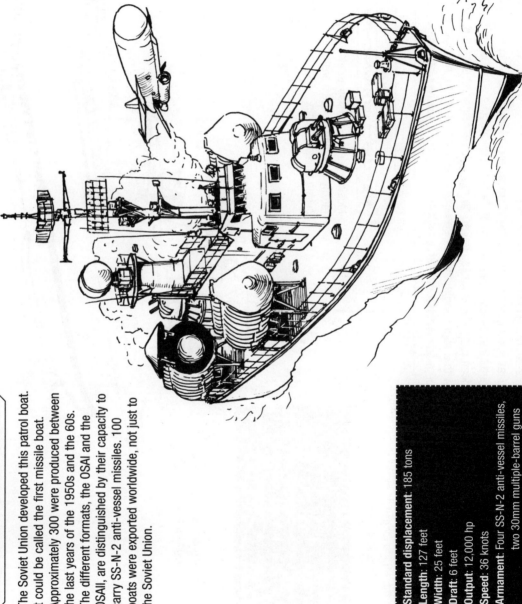

MISSILE SHIP OSA SERIES

The Soviet Union developed this patrol boat. It could be called the first missile boat. Approximately 300 were produced between the last years of the 1950s and the 60s. The different formats, the OSAI and the OSAII, are distinguished by their capacity to carry SS-N-2 anti-vessel missiles. 100 boats were exported worldwide, not just to the Soviet Union.

Standard displacement: 185 tons
Length: 127 feet
Width: 25 feet
Draft: 6 feet
Output: 12,000 hp
Speed: 36 knots
Armament: Four SS-N-2 anti-vessel missiles, two 30mm multiple-barrel guns
Crew:

Development of Stealth Warships

Stealth design aims to reduce detection by the enemy's sensors. Electric wave radar, heat, sound, and magnetic disturbances are all kept to a minimum. Radar is the best detecting device so reduction of detection by elective wave is the first thing to be dealt with. The simplest way to do this is to redesign the ship or its upper structure with a slight angle, thereby creating a diffused reflection. A proper stealth warship can be made without the aid of high-tech devices. It just requires some ingenuity.

FRANCE (1996)

LAFAYETTE-CLASS FRIGATE

Similar to the Visby Class, this ship was a thoroughly stealth frigate. All the small equipment, such as lifeboats, was stored inside the ship to reduce its exposure to detection by radio waves.

Displacement: 3,600 tons
Length: 410 feet
Speed: 25 knots
Armament: Two Exocet quadruple launch bays,
one Crotale short-range SAM
launcher, two 20mm guns
Number of aircraft: One helicopter

GERMANY

MEKO STEALTH WARSHIPS

Multiple purpose warship, used mostly for export. It was a best-selling frigate warship.

Crotale short-range SAM launcher

One 4-inch
single-barrel gun

It was designed with the greatest stealth capacity. The extent to which ship's edge juts out was minimized and the ship's body was painting with electric wave absorbing material. The incline of the ship's body diffuses electric wave reflection. The chimney, a potential cause of heat detection, was removed. Instead, exhaust after it has cooled is released into the water from the back of the ship.

Standard displacement: Approx. 600 tons
Length: 236 feet
Width: 33 feet
Output: 25,000 hp
Speed: 35 knots or more
Armament: One 57mm single-barrel gun, torpedo, RBS-15 anti-vessel missile, anti-submarine grenade launcher, and other armaments.

Crew: 34 to 44

This vessel is regarded as the epitome of 21st-century surface warship design. It is not only has stealth capacity against radar but also has infrared, sonar, and optic sensors.

Displacement: 2,500 tons
Length: 377 feet
Speed: 28 knots
Armament: Various missiles
Number of aircraft: One helicopter

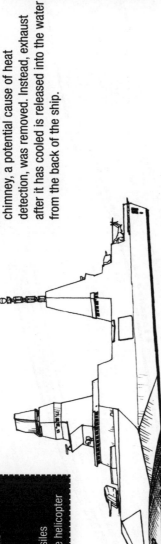

500 missiles in total, all of which can be fired vertically.

A large ship with a 20,000-ton displacement and 820 feet long. As part of its thorough stealth function, the deck has this shape, giving it an external experience resembling a contemporary tortoise deck boat. All the missile launchers are VLS and are installed as low as possible. As apparent from its appearance, this vessel is meant more as a missile firing platform rather than a ship.

UNITED STATES (1940)
GATO CLASS

205 of this class were produced between 1941 and 1944. Only the first ship was deployed when war broke out and came to be treated as a principal submarine in the U.S. Navy. Submersion depth is 295 feet but the SS-285 Balao and subsequent models went down to 394 feet. Approximately 20 of them were destroyed during the war. Many were sold to other countries after the war. Japan's Maritime Self-Defense Force rented one for training purposes, naming it Kuroshio.

Stern

Gato Class was equipped with four torpedoes launch bays just like other submarines at that time.

Sail

Initially the sail of a Gato Class was large. It was later scaled down in front and back and armed with two 20mm single-barrel guns. The anterior 20mm gun was subsequently switched to a 40mm.

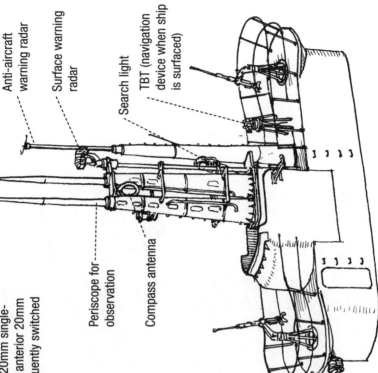

Anti-aircraft warning radar

Periscope for observation

Surface warning radar

Search light

TBT (navigation device when ship is surfaced)

Periscope for observation

Compass antenna

Periscope for observation

Displacement: 2,415 tons (when submerged)

Length: 312 feet
Width: 27 feet
Draft: 15 feet
Output: 5,400 hp

Speed: 20.3 knots or more
Armament: Ten 533 torpedo launch bays, one 5-inch single-barrel gun, one 40mm single-barrel gun

Crew: 80

Armament

There were many ships in this class and consequently many different armament and turret designs.

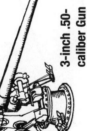

3-inch .50-caliber Gun

20mm Gun

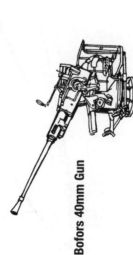

Bofors 40mm Gun

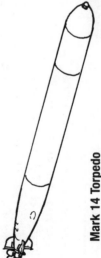

Mark 14 Torpedo
Infamous for often misfiring at the start of WWII.

U.S. Nuclear Submarine

UNITED STATES (1981)
STRATEGIC SUBMARINE OHIO CLASS

Displacement: 18,750 tons (when submerged)
Length: 560 feet
Width: 42 feet
Draft: 36.5 feet
Output: 60,000 hp
Speed: 20 knots or more
Armament: Twenty-four Trident SLBMs, four 21-inch torpedo launch bays
Crew: 155
Ships in the Same Class: 18

Ohio played a significant part in the U.S. nuclear armament. 18 of them were built between 1981 and 1997. It carries 24 SLBM. The Ohio is very long—shaped like a cigar. The large missiles were stored upright and the missile compartment was hence dubbed "Sherwood Forest."

Trident II

There are two types of Trident SLBMs: Type C-4 (3,800-mile firing range, accommodating eight 100,000-ton atomic warheads); Type D-5 (7,450-mile firing range, accommodating a dozen 100,000-ton atomic warheads). Type C-4 was installed in the first to eighth Ohio, and Type D-5 was in the ninth and after.

White marks drawn around the hatch.

Armament of U.S. Atomic-powered Attack Submarines

During the Persian Gulf War, the Los Angeles Class took a big part in attacking Iraq with Tomahawk missiles.

Tomahawk Cruise Missile

Sub-rocket Anti-submarine Missile

Sub-harpoon Anti-vessel Missile

It's a superlative nuclear submarine in every respect: maneuvering, armament, and sensor quality. Between 1976 to 1996, 62 of this class were constructed, nine of which have since been retired. From the 32nd onwards, VLS for Tomahawk missiles were installed. Now it not only goes after submarines of the same class but also strikes onshore targets.

Displacement: 6,927 tons (when submerged)
Length: 362 feet
Width: 33 feet
Draft: 32 feet
Output: 35,000 hp
Speed: 32 knots
Armament: Harpoon anti-vessel missile, Tomahawk anti-cruise missile, four torpedo launch bays, other bombs totaling 26 in number. Some of these submarines are equipped with twelve VLS for Tomahawk missiles.

Crew: 133

Displacement: 9,142 tons (when submerged)
Length: 353 feet
Width: 42 feet
Sea gauge: 36 feet
Output: 45,000 hp
Speed: 38 knots
Armament: Eight Torpedo launch bays containing a total of 50 missiles, including Tomahawk. Approximately 100 depth charges

Crew: 134
Ships in the Same Class: Connecticut, Jimmy Carter (both were under construction at the time of this writing)

Rudder. From the 40th ship, the rudder was moved to the bow.

Torpedo launch bay
Sublock and Harpoon are also fired from here.

From the 32nd ship, Tomahawk missile vertical launchers were equipped here.

Mark 48 Torpedo

A quieter and faster successor to Los Angeles Class. The square-shaped device on side is a sonar array. The cost of constructing a Sea Wolf soared so there were only three produced. US decided to obtain NSSN, which is a little inferior in quality compared to the Sea Wolf.

GERMANY (1936)
VII C TYPE

VII C Type is the principal U-boat, 620 of which were produced. In accordance with the radicalization of war, it started to install anti-aircraft armament as well as electric radar detection devices. This type came to be equipped with Snorkel at the end of WWII.

Though this is a submarine it went for surface attacks as much as possible. It tended to shoot down commerce ships with normal missiles rather than with a small number of torpedoes.

Displacement: 851 tons (when submerged)

Length: 220 feet
Width: 20 feet
Draft: 16 feet
Output: 1,400 hp
Speed: 10 knots when surfaced, 2 knots when submerged

Armament: Five 21-inch torpedo launch bays, one 3.5-inch single-barrel gun, one 20mm gun

Crew: 44
Ships in the Same Class: 600 or more

Flat Details

The flat is called the Winter Garden. A second layer was added in the latter half of the war and the anti-aircraft armaments were strengthened.

UZO long-range range finder

Periscope for detecting (when retracted)

Speaker tube

Vertically telescoping compass antenna

Control turret hatch is located between the periscope and the UZO.

Compass

Periscope for attack

Torpedo launch bay in the stern

3.5-inch Gun

Reused the army's 3.5-inch elevated guns. With the advent of aircraft radar, surface attack became impossible and guns on

20mm Machine Gun

A 20mm gun was not enough to defend against improved patrol ships. U-boats produced in the latter half of WWII were then equipped with anti-aircraft missiles. The sail was made larger

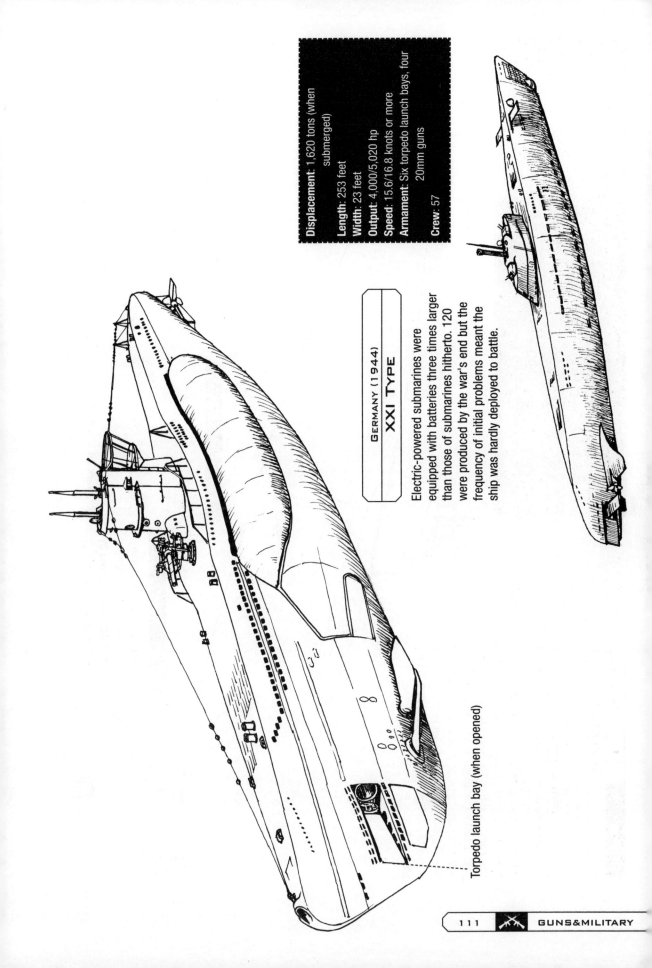

Displacement: 1,620 tons (when submerged)

Length: 253 feet
Width: 23 feet
Output: 4,000/5,020 hp
Speed: 15.6/16.8 knots or more
Armament: Six torpedo launch bays, four 20mm guns

Crew: 57

GERMANY (1944)
XXI TYPE

Electric-powered submarines were equipped with batteries three times larger than those of submarines hitherto. 120 were produced by the war's end but the frequency of initial problems meant the ship was hardly deployed to battle.

Torpedo launch bay (when opened)

BRITAIN (1983)
ATTACK SUBMARINE TRAFALGAR CLASS

Britain's latest submarine, its production lasted from 1983 to 1991. Noise reduction was a design imperative and thus the ship's body was coated with detector damping material. From 1994, a new and better type of torpedo called Spearfish was installed, making the ship even more powerful. Another two are now planned to be produced.

Displacement: 5,208 tons (when submerged)
Length: 280 feet
Width: 32 feet
Output: 15,000 hp
Speed: 32 knots
Armament: Harpoon anti-marine missile, six torpedo launch bays
Crew: 97
Ships in the Same Class: 7

Stonefish

Sub-harpoon Missile

Spearfish

Mark 24 Tigerfish

Torpedo Missiles

Screw

Propellers like this are common nowadays as they can restrain cavitation (the noise caused by the rotation of screws).

Though reloading isn't possible, there are four torpedo launch bays at the back.

There are a total of 12 torpedo launch bays.

A large sonar dome with the bow

ATTACK SUBMARINE DAPHNE CLASS

Typical motor-powered submarine. There are 11 of this type that France constructed between 1964 and 1970. It looks dated as seen in the picture below but there are still three of them in service.

Displacement: 1,038 tons
Length: 190 feet
Speed: 16 knots
Armament: Twelve 22-inch torpedo launch bays

It has a pressure chamber here so that crew can enter and leave the ship even when it is submerged.

YUGO CLASS SUBMARINE

North Korea also possesses typical motor-powered submarines but this Yugo Class submarine was captured by the Korean Navy in June 1998. It lacks armament and is used solely as a means for agents to infiltrate and escape. North Korea seems to use it in this peculiar way but also uses it as an ambush/attack submarine when at war.

Displacement: 110 tons
Length: 66 feet
Speed: 7.2 knots when submerged, 7.6 knots when surfaced
Crew: 19 (Initially it had two torpedo launch bays.)

France's Submarines

FRANCE (1934)

SURCOUF

With the intention to destroy commercial ships with its 8-inch cannon, the French navy constructed this submarine before the breakout of WWII. Among its several unique features is a huge caliber gun in front of the sail. (Since it couldn't rotate it was difficult to control.) Also a chamber for POWs, accommodating up to 40.

Displacement: 4,304 tons (when submerged)
Length: 360 feet
Width: 29.5 feet
Draft: 24 feet
Output: 3,400 hp
Speed: 10 knots or more
Armament: 8-inch multiple gun, 21-inch torpedo, twelve 16-inch launch bays, and several other armaments
Number of loading aircraft: One scout plane
Crew: 118
Ships in the Same Class: None

Anti-vessel missile Exocet

Sail

20.3cm gun with a maximum firing range of 24,000m. When surfaced, preparation to fires requires only 2.5 minutes. There is a range finder on top of the huge gun.

37mm gun

At the time of WWI, development of aircraft still hadn't really advanced so armaments like cannons were the means to destroying commercial ships. However, with the great advancements made with aircraft during WWII submarines required more stealth features (not just good armament).

Besson MB411 Surface Plane

Compact, it could be dismantled within 10 minutes and stored in a 52-foot-by 30-foot box. The navy needed this kind of scout plane to find its target as soon as possible.

Anti-vessel missile Exocet

FRANCE (1983)
ATTACK SUBMARINE RUBIS CLASS

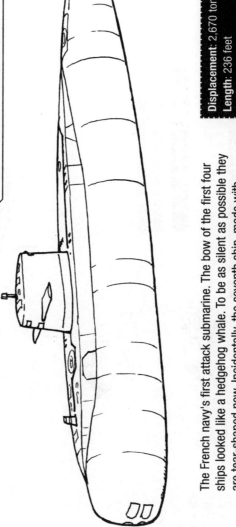

Displacement: 2,670 tons (when submerged)
Length: 236 feet
Width: 25 feet
Output: 9,500 hp
Speed: 25 knots
Armament: Four 21-inch torpedo launch bays,
Exocet anti-vessel missile
Crew: 70
Ships in the Same Class: 6

The French navy's first attack submarine. The bow of the first four ships looked like a hedgehog whale. To be as silent as possible they are tear-shaped now. Incidentally, the seventh ship, made with standard motor power, was converted into an export ship. During the Falklands War, Exocet was installed and gave Britain a hard time. The maximum range was approximately 45 miles and is used by more than 10 countries. Also, France's torpedoes have traditionally been 21 inches since the time of Surcouf but with recent disarmament agreements with other NATO countries, they will be revamped.

SOVIET UNION (1980)
CRUISING MISSILE SUBMARINE OSCAR CLASS

Except for strategic nuclear submarines, this is the biggest submarine in the Russian fleet. The next largest nuclear-powered submarines are the Typhoon and the Ohio. It mainly aims to attack the enemy's ships with long-range anti-vessel missiles. Their enemy was most likely to be a carrier fleet of the other superpower, the United States. There are 12 SS-N-19 missiles installed on each side of the ship so the width of the submarine was wider than others.

Displacement: 12,500 tons (when submerged)

Length: 470 feet
Width: 60 feet
Output: 98,000 hp
Speed: 30 knots
Armament: Twenty-four SS-N-19 anti-vessel missiles, twenty-eight torpedoes (eight launch bays)

Crew: 130
Other similar submarines: At least 12, including Tambov, Smolensk. (Oscar is a NATO code name.)

SS-N-19 Cruising Missile

Installed in the Oscar Class. Oscar can carry atomic bombs.

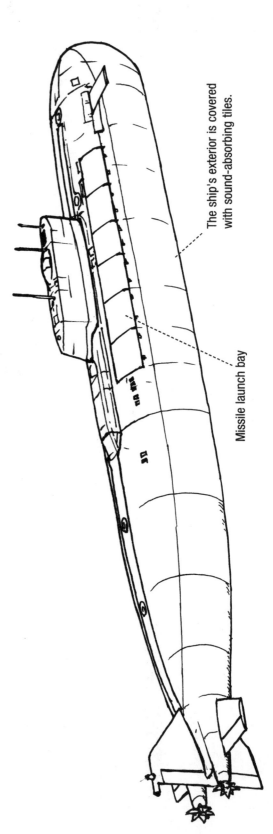

The ship's exterior is covered with sound-absorbing tiles.

Missile launch bay

Displacement: 24,500 tons (when submerged)

Length: 574 feet
Width: 75 feet
Output: 100,000 hp
Speed: 25 knots
Armament: Twenty SS-N-20SLBM, eight torpedo launch bays

Crew: 150
Ships in the Same Class: 6

SOVIET UNION (1983)
STRATEGIC SUBMARINE TYPHOON CLASS

The world biggest nuclear submarine with strategic missiles. The submarine in the film "Hunt for Red October" was based on this model. Six submarines were commissioned between 1981 and 1998. Since missiles were located in front of the sail, this submarine looked quite different from those made in the West. The sail was made strong so that missiles could penetrate the ice under the Arctic Ocean.

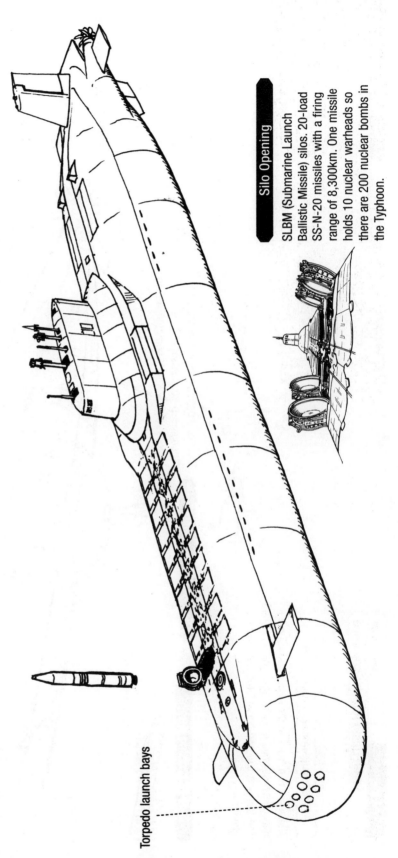

Torpedo launch bays

Silo Opening

SLBM (Submarine Launch Ballistic Missile) silos. 20-load SS-N-20 missiles with a firing range of 8,300km. One missile holds 10 nuclear warheads so there are 200 nuclear bombs in the Typhoon.

Akula Armament

25.5-inch 65-Type Torpedo

21-inch Anti-submarine Guided Torpedo

SS-N-15 anti-vessel missile

Decoy

Soviet Union Attack Submarine

SOVIET UNION (1985)
ATTACK SUBMARINE AKULA CLASS

There are two types in the Akula Class: Type I was commissioned in 1986 and Type II in 1995. The sail was low and curved, different from others.

SS-N-21 Cruising Missile

Akula Class Sail

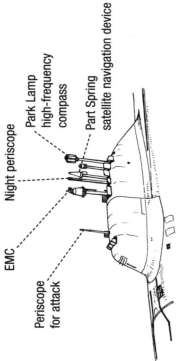

Night periscope

Park Lamp high-frequency compass

Part Spring satellite navigation device

EMC

Periscope for attack

The many projections in the sail are various deep-sea sensors, demonstrating Akula's competitive edge.

It was initially said to be the latest slow propulsion system. It was, in fact, a pod containing a tugboat sonar.

Torpedo launch bay

Displacement: 9,500 tons (when submerged)
Length: 354 feet
Width: 44 feet
Output: 43,000 hp
Speed: 28 knots
Armament: SS-N-21 anti-ground cruise missile, SS-N-15 anti-vessel missile, six torpedo launch bays
Crew: 85
Ships in the Same Class: 11, including both Type I and II

A quieter version of the Akula II with greatly enhanced sensors. Its long body looks like a torpedo. Both classes are nuclear powered attack submarine, equivalent to U.S.-built attack submarines.

Displacement: 11,800 tons (when submerged)

Length: 394 feet

Width: 49 feet

Speed: 28 knots

Armament: SS-NN-26 anti-vessel missile, SS-N-21 anti-ground cruise missile, six torpedo launch bays

Crew: 73

In the postwar era, the United States developed models from M26 to M60 to compete with the Soviet Union's military vehicles. But as we have seen with the models from T54 to T72, the Soviet Union always seemed to maintain superiority to the United States when it came to military vehicles. The United States designed and developed this M1 with a completely new concept in order to reverse the situation. M1 initially had a 105mm gun, but soon this was switched to a 120mm gun and became M1A1. This vessel destroyed Iraqi's T72 in the Gulf War. The would-be problematic gas turbine, in fact, worked perfectly and therefore it has been proved itself to be the world's strongest battle tank.

UNITED STATES (1984)
M1A1

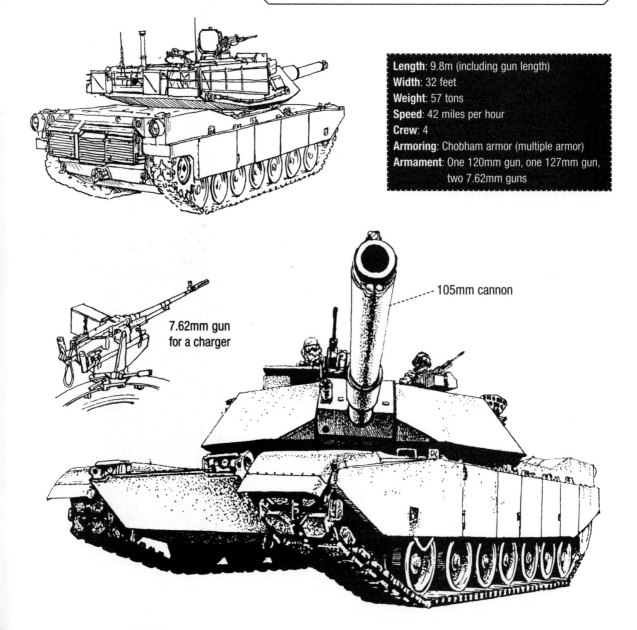

Length: 9.8m (including gun length)
Width: 32 feet
Weight: 57 tons
Speed: 42 miles per hour
Crew: 4
Armoring: Chobham armor (multiple armor)
Armament: One 120mm gun, one 127mm gun, two 7.62mm guns

105mm cannon

7.62mm gun for a charger

Latest model from the M1 series. Gas-turbine powered, while MBT (main battle tanks) in other countries are all diesel-powered. With 1,500 horsepower, this battle tank can travel at 41 miles per hour (36 miles per hour on rough terrain).

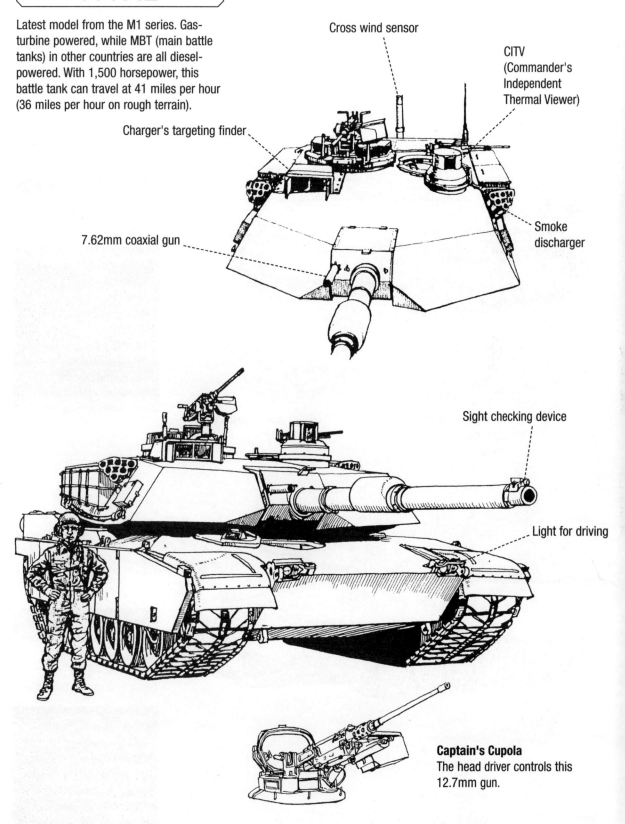

Cross wind sensor

CITV (Commander's Independent Thermal Viewer)

Charger's targeting finder

Smoke discharger

7.62mm coaxial gun

Sight checking device

Light for driving

Captain's Cupola
The head driver controls this 12.7mm gun.

Known as "battle tank kingdom", Germany produced this battle tank first after WWII. Focused on firepower and maneuvering, its main gun is 105mm, which is also used as a standard NATO gun. It is a very balanced battle tank and is also used by NATO allies, such as Belgium, Holland, Italy, and Canada.

GERMANY (1966)
LEOPARD BATTLE TANK

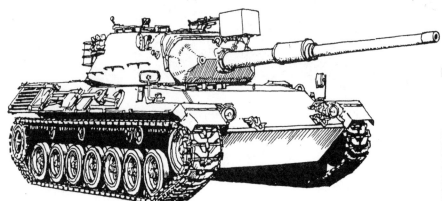

Leopard I

Improved in many aspects. Still in use today.

Length: 31 feet (including gun length)
Width: 10.5 feet
Weight: 39.6 tons
Speed: 40 miles per hour
Crew: 4
Armoring: 0.3 inches to 2.75 inches
Armament: One 105mm cannon, two 7.62mm guns

Smoke discharger
Essential in recently made battle tanks

7.62mm Anti-aircraft Gun
Charger Hatch

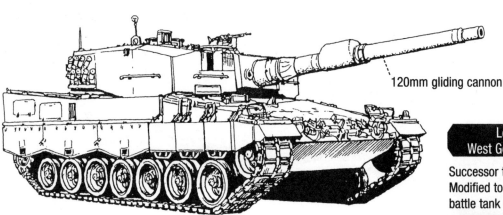

120mm gliding cannon

Leopard II
West Germany (1978)

Successor to Leopard I. Modified to be the main battle tank during the 1980s.

Length: 32 feet (including gun length)
Width: 25 feet
Weight: 55 tons
Speed: 45 miles per hour
Crew: 4
Armoring: Chobham armor
Armament: One 120mm cannon, two 7.62mm guns

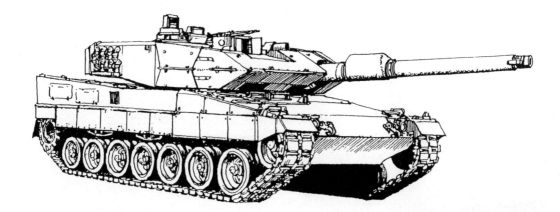

Latest version from Leopard series. Additional armoring covered with a turret, making the tank clearly different from the previous Leopard.

Leopard Series' Turret

This was the first use of the 120mm cannon in the West and has since become a world-standard cannon.

I

II

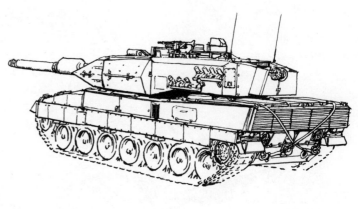

Panoptic device

II A 5

Modern electronics and stronger turret were the main improvements of II A 5.

Also called "Ural" in Russia. It was systematized in 1973 and has been modified many times since. Many of them were actively exported to other countries from 1975. Some countries are licensed to produce this model.

Since the end of WWII, the Soviet Union had always been one step ahead of the United States in the respect of battle tanks. This is apparent when we look at the U.S. M48 (90mm cannon in 1953) and M60 (105mm cannon in 1958) versus the Soviet Union's T-54 (100mm cannon in 1950) and T-62 (155mm smoothbore in 1960). T-72 was produced for use against western battle tanks with a 120mm cannon. Here, a 125mm gliding cannon is accompanied with automatic charging device. This tank incorporates many such progressive ideas, including the reduction of the crew to three people.

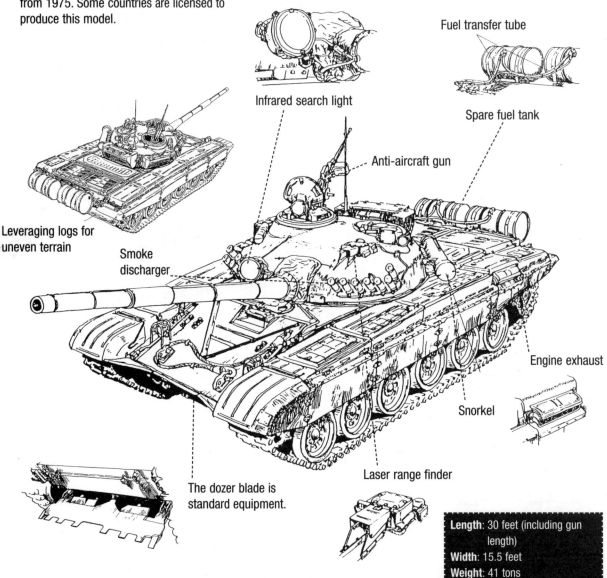

Fuel transfer tube

Infrared search light

Spare fuel tank

Anti-aircraft gun

Leveraging logs for uneven terrain

Smoke discharger

Engine exhaust

Snorkel

The dozer blade is standard equipment.

Laser range finder

Length:	30 feet (including gun length)
Width:	15.5 feet
Weight:	41 tons
Speed:	50 miles per hour
Crew:	3
Armoring:	
Armament:	One 125mm cannon, one 12.7mm gun, one 7.62mm gun

SOVIET UNION (1985)
T-80U

The first gas turbine-powered tank of the Soviet Union, a hugely modified model of the T-80. AT-11 sniper missile can be loaded in 125mm smoothbore. Reactive armor is added to an additional armoring. It looks like a helmet crab.

Length: 23 feet (including gun length)
Width: 12 feet
Weight: 46 tons
Speed: 44 miles per hour
Armament: One 125mm cannon, one 12.7mm gun, one 7.62mm gun

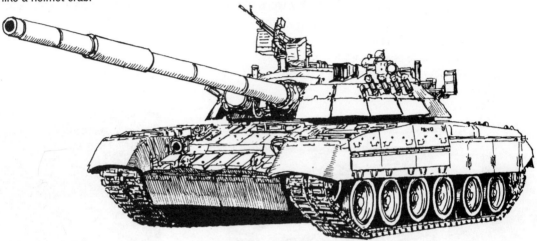

SOVIET UNION (1983)
T-90

The latest model from Russia. Its defensive armoring is worth mentioning as there are more than five layers of armoring to increase the chances of survival. Its capacity is almost the same as T-80 but its reliability and operation were improved.

Length: 23 feet (including gun length)
Width: 12 feet
Weight: 46 tons
Speed: 44 miles per hour
Armament: One 125mm cannon, one 12.7mm, one 7.62mm

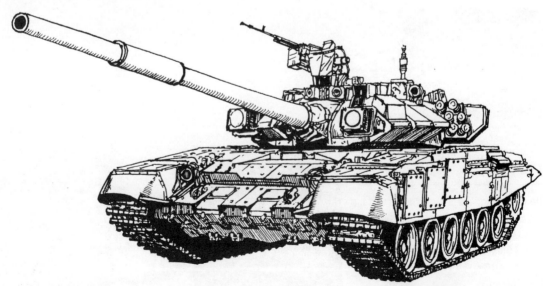

A self-propelled gun is a field gun with self-propelling capacity. A mechanized unit became the main force in the WWII and the gun operation unit subsequently required mobility. These two factors led to the development of self-propelled guns throughout the world. Its main mission is to support attack from the rear. Its armoring used to be thin but gradually obtained better armoring like a revolving gun turret and looks similar to battle tanks. Many types of self-propelled guns were made for anti-tank, anti-aircraft, rocket-loading and other uses.

UNITED STATES (1944)
M40 SELF-PROPELLED GUN

A full-scale self-propelled gun equipped with a 155mm cannon. The vehicle itself is M4A3E8. Delays in its completion meant that it couldn't be actively used until the time of the Korean War. Said to be the most complete tank of WWII, it was nicknamed Big Shot.

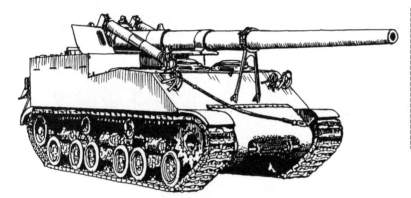

Length: 22 feet (including gun length)
Width: 10 feet
Weight: 37.2 tons
Speed: 24 miles per hour
Crew: 8
Armament: One 155mm cannon
M43 self-propelled howitzer with a 203mm cannon was also produced.

GERMANY (1994)
155MM SELF-PROPELLED PzH 2000

The latest German self-propelled gun. Range 18 miles, accompanied with automatic charger. More than 60 bullets can be loaded.

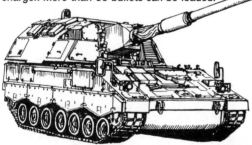

Length: 38 feet (with gun length)
Width: 11.5 feet
Weight: 55 tons
Speed: 37 miles per hour
Armament: One 155mm cannon, one 7.62mm gun

JAPAN (1975)
YEAR 75 SELF-PROPELLED 155MM HOWITZER SHELL

Japan rented and purchased them from the United States and developed them as successors to old self-propelled guns. It can fire 18 bullets per minute with an automatic charge in a revolver-style magazine.

Length: 25.5 feet (including gun length)
Width: 10 feet
Weight: 25 tons
Speed: 29 miles per hour
Crew: 6
Armament: One 155mm howitzer shell, one 12.7mm gun

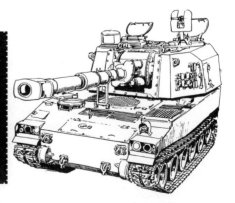

227mm-diameter Rocket Bomb
The head can be switched to suit the target (tanks, people or land mines).

ATACMS Missile
Firing range over 80 miles. Ground-to-ground missile. The launch pod stores one missile.

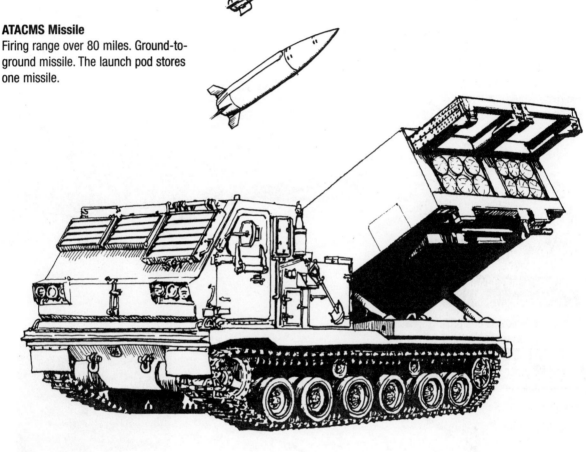

Launch Pod Container
(includes 6 rocket bombs)

Launch Rotor Module

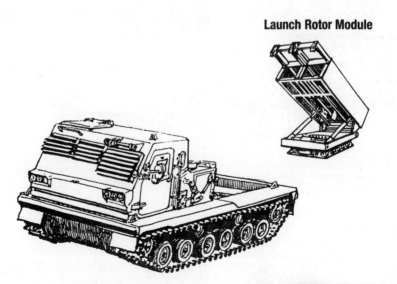

Self-propelled launcher
Weight: 24.5 tons
Speed: 40 miles per hour
Crew: 3
Range: 20 miles

GERMANY (1940)
STURMGESCHUTZ III

Assault guns were originally developed to support the infantry and to destroy the enemy's "pillbox" and territory from a short distance. Later they were used to attack enemy battle tanks. They were equipped with a long-range cannon that could pierce any sort of armoring. They officially became self-propelled guns from the middle of WWII.

Sturmgeschutz III Ausf.B
Germany (1942)

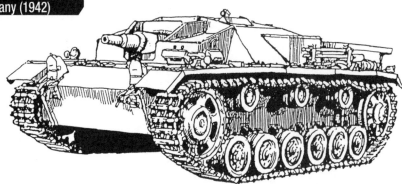

Sturmgeschutz III Ausf. G
Germany (1942)

This battle tank was equipped with a 75mm cannon to defeat the T-34 made in the Soviet Union. This was a very important ground force for Germany as it suffered from a significant shortage of battle tanks.

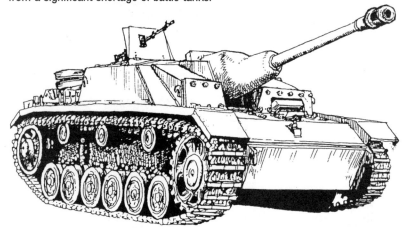

Length: 22 feet (including gun length)
Width: 9.5 feet
Weight: 23.9 tons
Speed: 25 miles per hour
Crew: 4
Armoring: 50mm
Armament: One 75mm cannon, two 7.92 mm guns

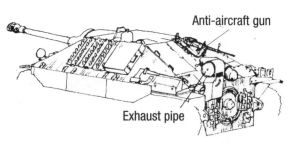

Anti-aircraft gun

Exhaust pipe

This is an anti-tank self-propelled gun and attacks the enemy's battle tanks. "(t)" means that it was originally Czech. (Germany amalgamated former Czechoslovakia and absorbed its military force before the WWII.)

Remote-controlled 7.92mm gun

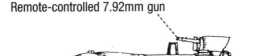
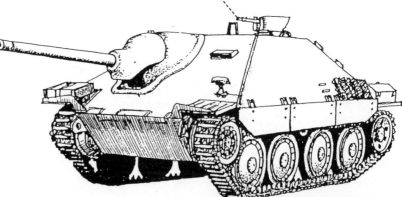

Length: 19 feet (including gun length)
Width: 7 feet
Weight: 16 tons
Speed: 26 miles per hour
Crew: 4
Armoring: 60mm
Armament: One 75mm cannon, one 7.92mm gun

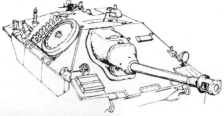

G-13 Tank Destroyer

75mm cannon was installed in this small body. It is easy to control this anti-tank self-propelled gun, which has been used in Switzerland after WWII. The Swiss named it G-13.

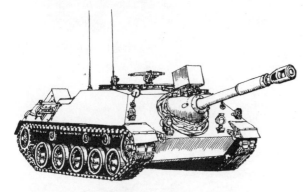

A developed model of KJPZ4-5. Anti-tank missile, TOW is equipped on this tank. It is now common for many countries to have anti-tank missiles.

TOW missile launcher

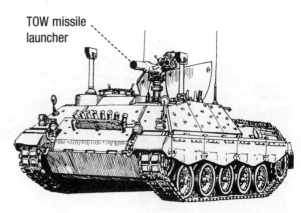

Self-propelled gun developed by Germany after WWII. Its very low height of just under 7 feet makes it best for ambush operations.

Length: 20.5 feet (including gun length)
Width: 9.75 feet
Weight: 27.5 tons
Speed: 44 miles per hour
Crew: 4
Armoring: 12mm to 50mm
Armament: One 90mm cannon, one 7.62 mm gun

Roller used for obstacles and uneven terrain

UNITED STATES (1941)
M3 HALF TRACK

This vehicle was made for transporting mechanized units so as to let infantry go along with battle tanks. Half Track means the combination of battle tank and caterpillar tread. It has tires in front and track at the back. Frequently used by the US and Germany during WWII. 12,499 were produced and used heavily among the Alliance. With its relatively large crew room, this type is also used as a self-propelled gun.

Length: 21 feet
Width: 7 feet
Weight: 9.1 tons
Speed: 5 miles per hour
Crew: 13
Armoring: 6.35mm to 12.7mm
Armament: One 12.7mm gun, two 7.7mm guns

Winch

UNITED STATES (1977)
M2/3 BRADLEY INFANTRY BATTLE TANK

M2 infantry battle tank is a progressed model of APC (armored personnel carrier) whose history began with M3 Half Track. It goes on operation along with other battle tanks while firing at the enemy. Its anti-tank ability has proven that it is more powerful than an older, light-weight battle tanks. M3 has the same design as M2, but is separated from cavalry battle tanks, and used as scouting. By reducing the number of crew, there is more space for bullet storage.

Small hatch
Entrance when the main hatch is not opened.

Main hatch (with ramp)
Infantry can easily exit from here.

Length: 21 feet (including gun length)
Width: 10.5 feet
Weight: 22.6 tons
Speed: 41 miles per hour
Crew: M2: 9; M3: 5
Armament: One 25mm cannon, one 7.62mm gun, two TOW missiles

TOW missile. Launcher is located on the left side.

Smoke discharger

25mm chain gun which can be also used for anti-aircraft attack.

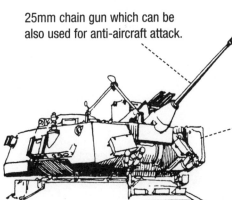

TOW anti-tank missile launcher (holds 2 missiles)

7.62mm coaxial gun

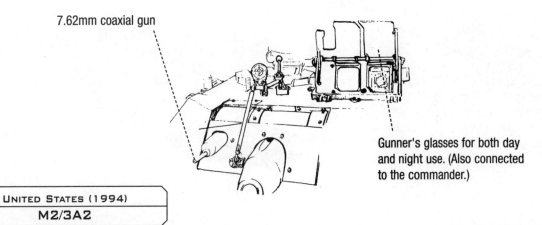

Gunner's glasses for both day and night use. (Also connected to the commander.)

The latest model with stronger armoring. It is possible to exchange the data with other M1A2 and coordinate operation.

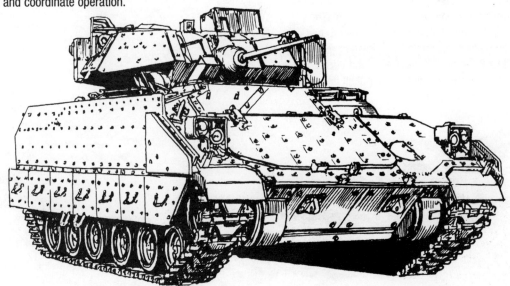

Hitler's passion for innovation led to the development of several unique aircraft. Here are some examples from Germany and elsewhere that actually took flight.

Blohm & Voss Bv-141 Scout Plane

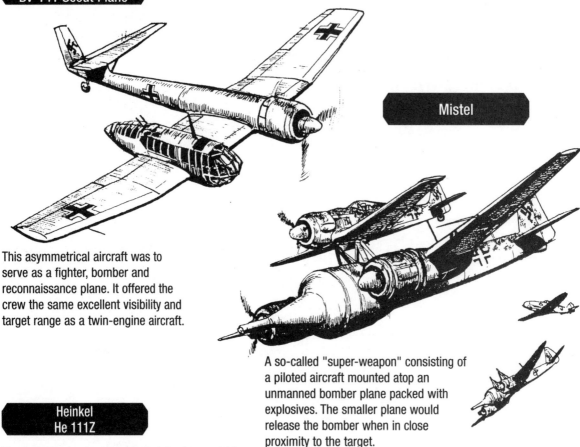

Mistel

This asymmetrical aircraft was to serve as a fighter, bomber and reconnaissance plane. It offered the crew the same excellent visibility and target range as a twin-engine aircraft.

A so-called "super-weapon" consisting of a piloted aircraft mounted atop an unmanned bomber plane packed with explosives. The smaller plane would release the bomber when in close proximity to the target.

Heinkel He 111Z

Two twin-engine bombers were joined to a middle section with its own engine (for a total of five). The wingspan of this immense aircraft, designed to tow the even larger Messerschmitt 321 transport glider, was 115 feet 6 inches. It is believed that a dozen (including two prototypes) were built, but all had been destroyed by war's end.

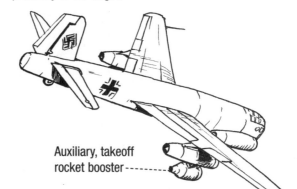

Auxiliary, takeoff rocket booster --------

Junkers Ju 287V1

This was the world's first plane with forward-swept wings. Equipped with four jet engines, it was designed to reach a top speed of 560 mph. Only one was built, though the Soviet Union continued its development following the war.

Messerschmitt Me323 Gigant

Measuring 93.5 feet long and boasting a wingspan of 180.5 feet, the Me 323 was among largest aircraft to fly during the war. It was basically an Me 321 outfitted with four (later six) engines, and had tremendous capacity for transport. But it was also painfully slow, making it an easy target for enemy fighters.

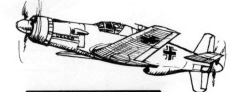

Focke-Achgelis Fa223

The first transport helicopter in the world. A total of 20 were produced by Germany during the war.

92 Type Bomber

A gigantic Japanese aircraft based on German Junkers G38. With a wingspan of 144 feet and overall length of 76 feet, it could compete with the B29 in terms of size. First built in 1932.

Dornier Do336

This unique aircraft had engines mounted in both the nose and the tail, and could achieve a top speed of 472 mph.

Mammoth

Dornier DOX

One of the largest so-called "flying boats," the DoX was outfitted with 12 engines and could carry up to 150 passengers and crew. Measured 133 feet long with a wingspan of 157 feet. Introduced in 1929.

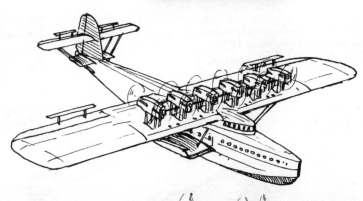

ANT-20 Maksim Gorky

The Soviet Union unveiled the largest pre-World War II aircraft, the "Maksim Gorky," in 1934. The eight-engine "propaganda plane" (so-named by the Soviets themselves) was 108 feet long, boasted a 206-foot wingspan, could accommodate up to 80 passengers and crew.

AVIATION

Unreal Aircraft

Largest in the World

The bigger the better. It's an old saying, but it still rings true when describing aircraft such as those pictured here.

UNITED STATES (1947)
HK-1/H-4 HERCULES FLYING BOAT

Length: 219 feet
Wingspan: 320 feet
Wing Area: 11,430 square feet

The company owned by the famously wealthy Howard Hughes designed and constructed this single-hull, wooden craft, nicknamed the "Spruce Goose." Although it remains the largest aircraft ever built, it only flew once, on Nov. 2, 1947. With Hughes himself at the controls, the graceful craft rose just a few feet above the water and traveled a single but historic mile before making a perfect landing.

UNITED STATES (1946)
CONVAIR B-36D PEACEMAKER

The world's largest bomber. This mighty aircraft—six radial engines, four jets, a 10,000-mile range and a 86,000-pound payload—served as a most-effective nuclear deterrent during the first two decades of the Cold War. Appropriately nicknamed "Peacemaker," it never was used in combat.

Length: 162 feet 1 inch
Wingspan: 230 feet
Speed: 439 mph
Range: 10,000 miles
Armament: two 20mm remote-controlled cannons in each of six turrets, 86,000-pound bomb payload

UKRAINE/SOVIET UNION (1988)
ANTONOV AN-225 MRIYA

Currently the biggest aircraft in the world. A gigantic aircraft produced for a transportation of space shuttles in the former Soviet Union.

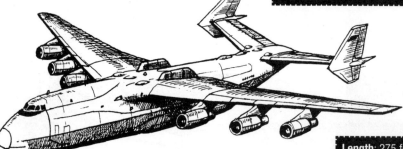

Length: 275 feet
Wingspan: 290 feet

MYASISHCHEV M50 BOUNDER

Development of this aircraft alarmed the West, which feared the Soviets could use nuclear-armed M50s to strike the United States. However, the Bounder turned out to be an experimental aircraft and never a true threat. The science fiction-esque design of the M50, which had a wingspan of 83 feet, inspired many comic book artists of the era.

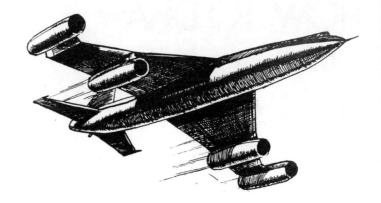

UNITED STATES (1964)

NORTH AMERICAN XB-70 VALKYRIE

Capable of flying at three times the speed of sound (Mach 3), the exotic Valkyrie was developed to be the fastest strategic bomber of its time.

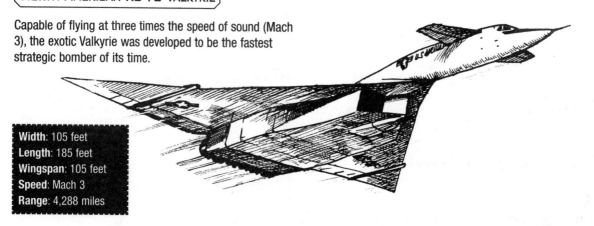

Width: 105 feet
Length: 185 feet
Wingspan: 105 feet
Speed: Mach 3
Range: 4,288 miles

SOVIET UNION (1981)

TUPOLEV TU-160 BLACK JACK

The world's largest modern bomber
(For more information, see page 57.)

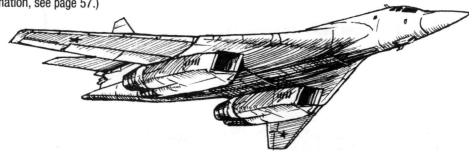

UNITED STATES (1989)

NORTHROP GRUMMAN B-2 SPIRIT

The flying-wing stealth bomber
(For more information, see page 46.)